W9-BIC-365

D HIGHLI

eople; it's known as the "great earthquake" until the earthquake in 1906. 1869 The Transcontinental Railroad is completed. 1870 San Francisco becomes the 10th largest ity in the U.S. 1870s John McLaren arrives in San Francisco and begins to plan Golden Gate Park. By 1890, he has established grass, trees, and plants in an environment nost thought too barren for lush foliage. 1871 The San Francisco Art Association and he California Historical Society are founded. 1873 The Clay Street Hill Railroad, the vorld's first cable car company, begins carrying passengers on San Francisco's first cable ar. 1882 The San Francisco Stock Exchange is founded. 1892 John Muir begins the ierra Club in San Francisco. 1906 On April 18, an enormous earthquake spreads across an Francisco destroying homes, opening streets, splitting sidewalks, and causing massive res that finally die out in the early morning of April 21. Approximately 3,000 people are illed; 250,000 people are left homeless. 1915 The Panama-Pacific International Exposition is held in San Francisco, celebrating the completion of the Panama Canal as vell as a commemoration of the 400th anniversary of the discovery of the Pacific Ocean. The fair is a huge success. • Development begins in the Marina District. 1920 The ACLU is founded in San Francisco by Roger Baldwin. 1929 The opening of the Great Highway and Ocean Beach Esplanade attracts more than 50,000 people. 1933 The onstruction of the Golden Gate and Oakland Bay Bridges begins. The idea for the Golden Gate Bridge was first proposed by the city's self-proclaimed "Emperor Norton" in 869. • America's oldest professional ballet company, *The San Francisco Ballet*, is ounded. 1934 A coast-wide strike occurs when the International Longshoremen's Association demands better hours and pay. On "Bloody Thursday," two strikers are killed n clashes with police. For three days the city is gripped by a general strike. It ends when

Vintage SAN FRANCISCO

WHAT I LIKE BEST

about San Francisco is San Francisco. Frank Lloyd Wright

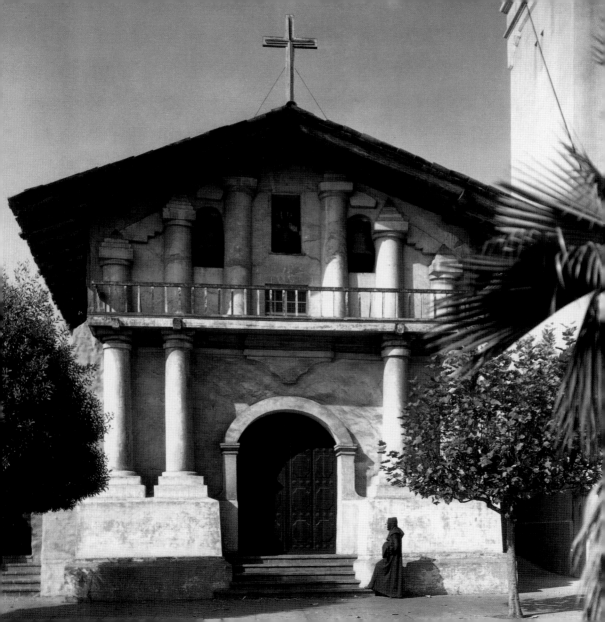

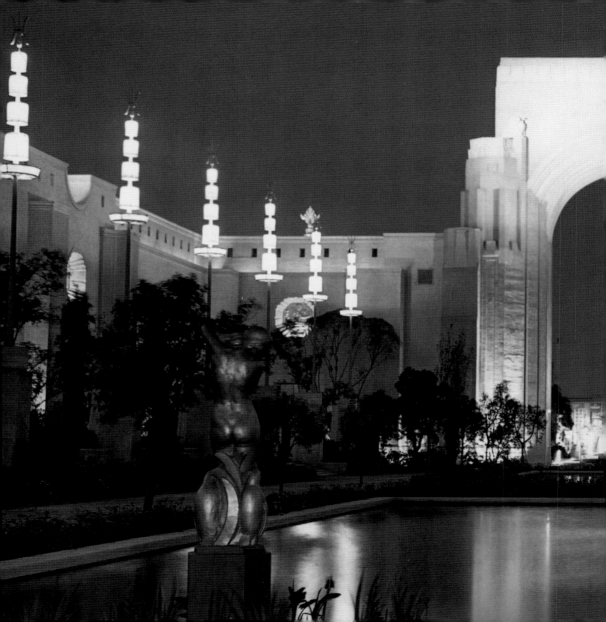

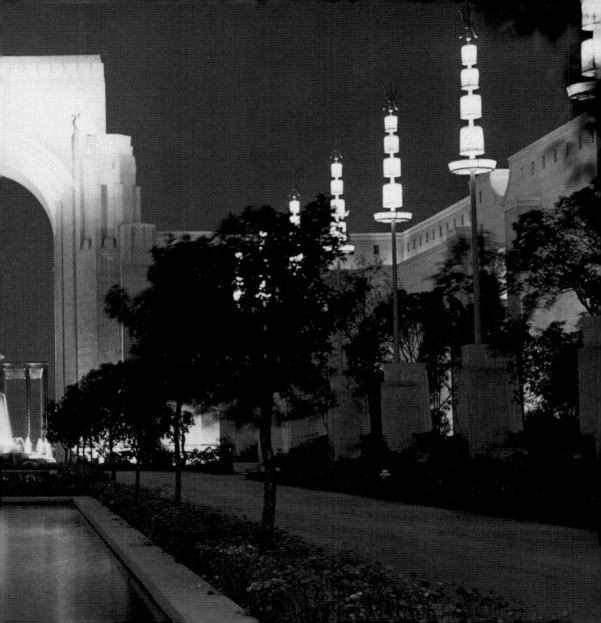

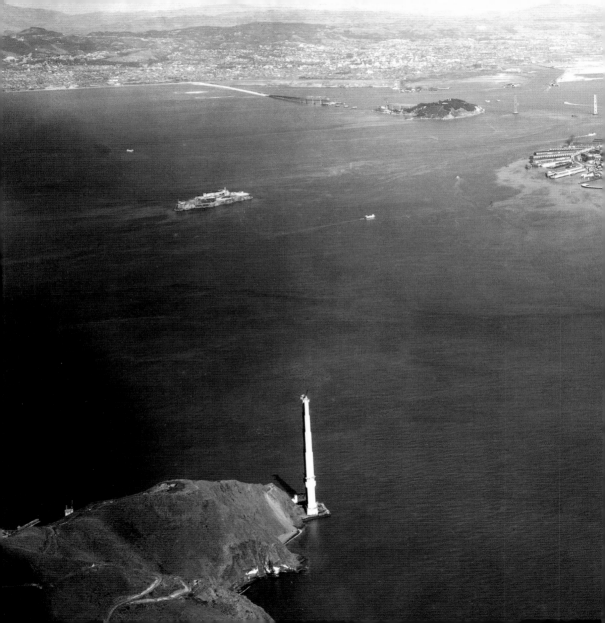

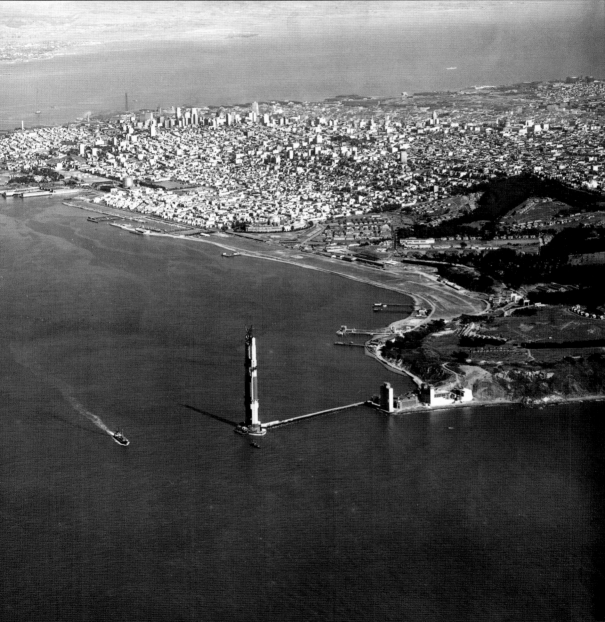

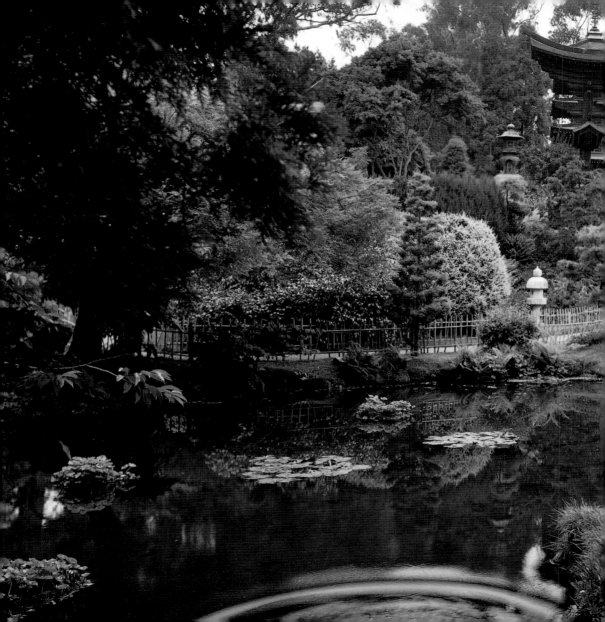

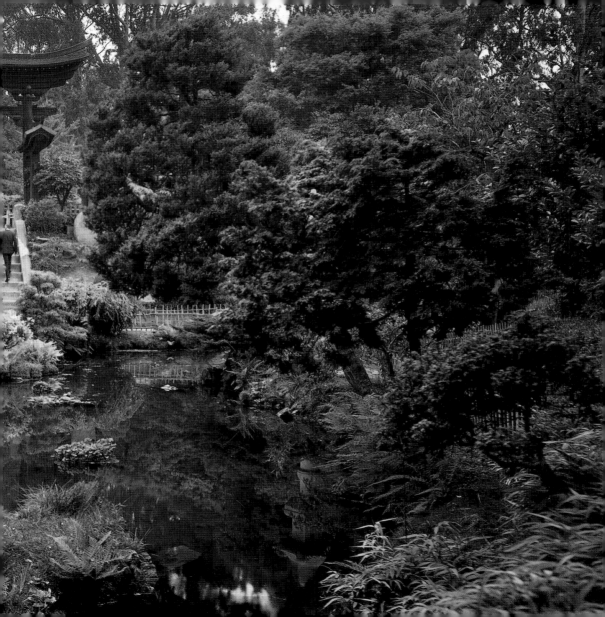

IT IS an odd thing, but every
one who disappears is said to be
seen in San Francisco. It must be a
delightful city; and possess all the
attractions of the next world.

Oscar Wilde

(preceding spreads)
*The Mission San Francisco de Asis, more well known as Mission Dolores, was founded in downtown
San Francisco in 1776; The Court of Reflection and the Arch of Triumph at San Francisco's 1939-1940 Golden
Gate International Exposition; Construction on both the Golden Gate and the San Francisco-Oakland
Bay Bridge was well under way by May 3, 1935; Golden Gate Park's timeless Japanese Tea Garden, 1962.*

(right)
*Southern Pacific's trains transported passengers to and from the East Bay and San Francisco
with tracks on the Bay Bridge. Later replaced by the Key System and, still later, the BART,
these trains ran to the Transbay Terminal at First and Mission, c. 1940s.*

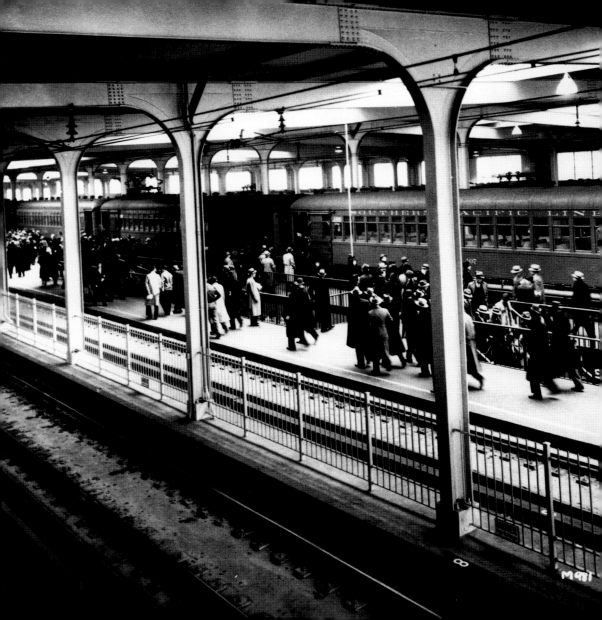

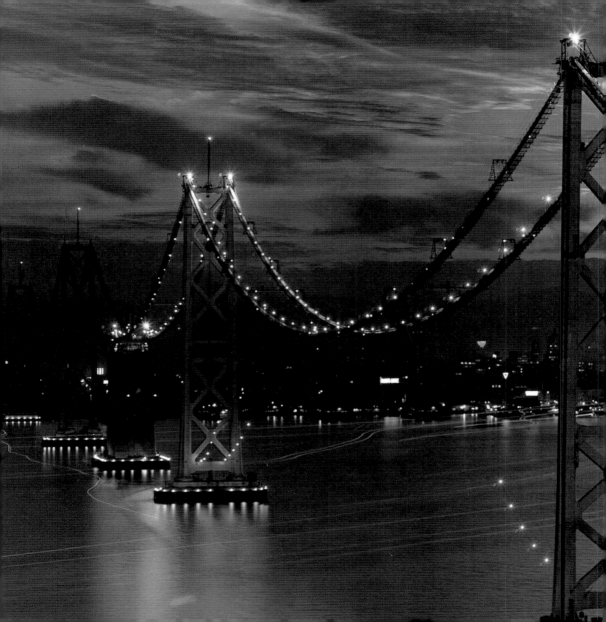

Edited by Peter Beren
Photographs by Moulin Studios

Vintage
SAN FRANCISCO

welcome
BOOKS

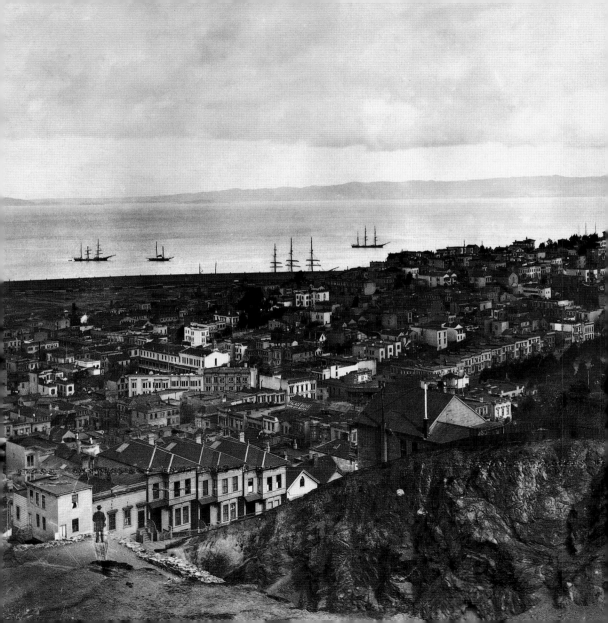

YOU WOULDN'T think such a place as San Francisco could exist. The wonderful sunlight there, the hills, the great bridges, the Pacific at your shoes. . . The lobsters, clams, and crabs. Oh, Cat, what food for you. Every kind of seafood there is.

Dylan Thomas,
in a letter to his wife, Caitlin

15

(preceding spread)
The suspension section of the San Francisco-Oakland Bay Bridge, still deckless, stretched from the city to Yerba Buena Island. The bridge opened on November 12, 1936, and immediately experienced a traffic jam.

(left)
Looking toward the Bay from Russian Hill in the 1880s. The castle-like Telegraph Hill Observatory at upper right stood near the future site of Coit Tower from 1882 to 1903.

THE POOLS themselves were a wonder. You could plummet into the water from diving platforms up in the rafters; rocket into the pools down giddy slides. . . whirl into the water from a carousel; swing out over the pools on trapeze-like rings. . . In memory, at least, these were pools to surpass the fabled spas of Europe and the Lucullan baths of the Roman Empire.

Harold Gilliam

Built beside the Cliff House in 1896, the Sutro Baths offered both saltwater and freshwater pools. The baths were destroyed by fire in 1966.

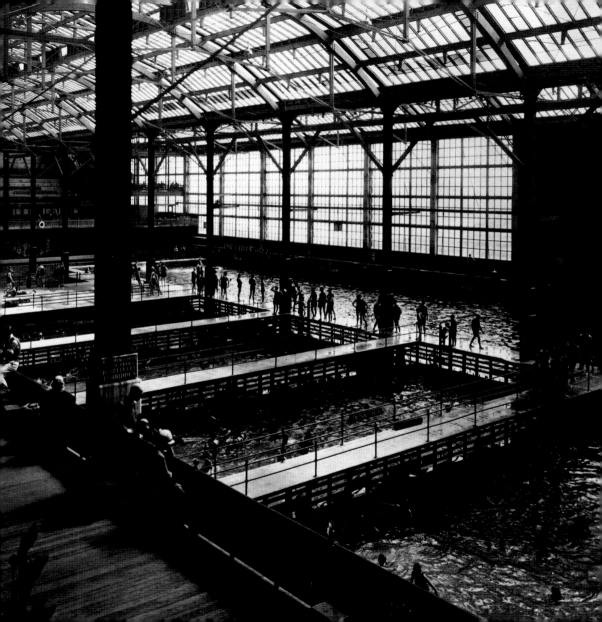

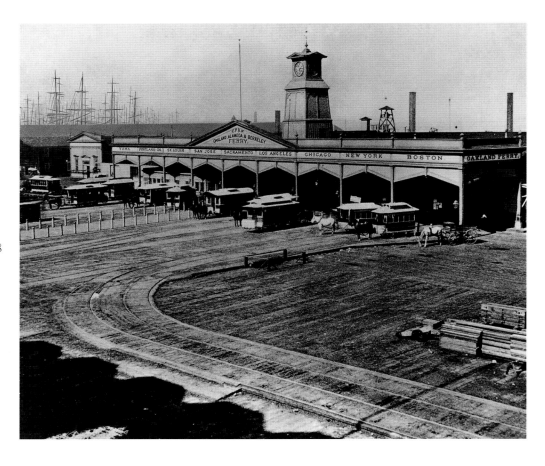

Streetcars connected with ferry boats at the foot of Market Street. The original Ferry Building, shown here, was built by the Central Pacific Railroad. It was replaced by the current Ferry Building in 1898.

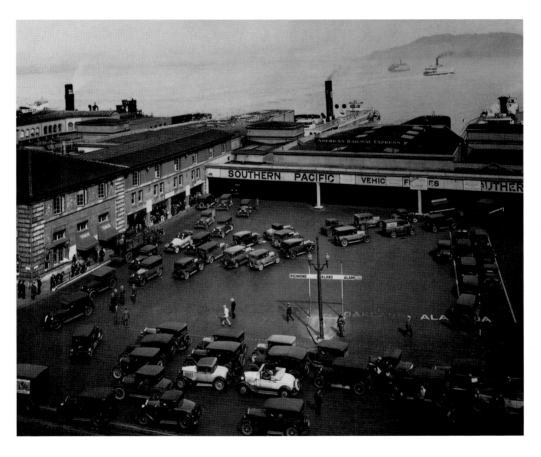

Cars lined up for the transbay ferries at the foot of Market Street, c. 1922.

IF IT COULD be well-settled like Europe, there would not be anything more beautiful in all the world.

20

Father Pedro Font, 1776,
on the land that was to become San Francisco

Crocker Building, corner of Market and Montgomery, 1890s.

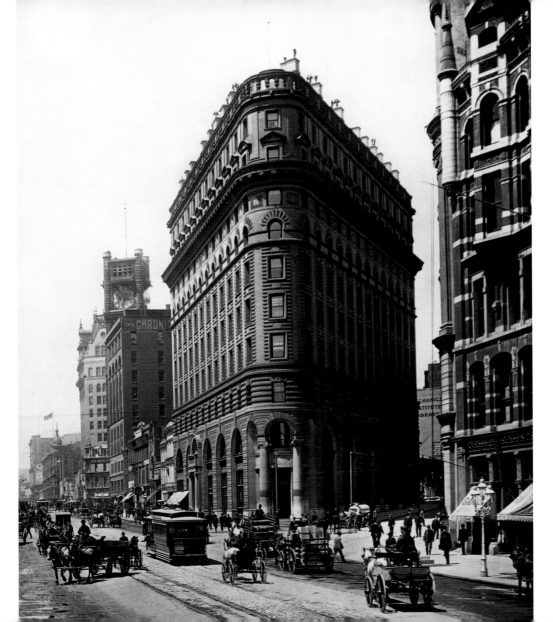

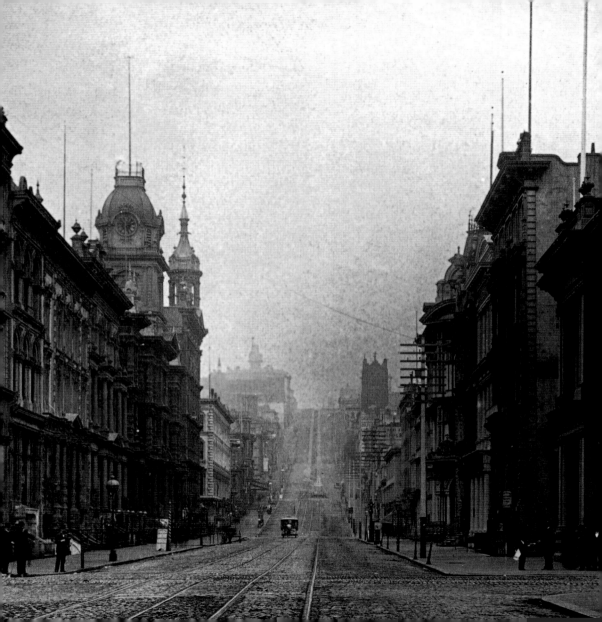

THE VISITOR WHO arrives in San Francisco from the sea is first amazed at the grandeur of the bay. Then he finds himself abruptly in the main streets where business is concentrated. . . to produce the effect of a suddenly risen city of enchantment. . . Kearney, Montgomery, Market, California, Sacramento streets are characteristic in their magnificence and wealth.

23

Guillermo Prieto, 1877

California Street climbed Nob Hill in the 1890s.
Old St. Mary's church tower can be seen on the right side
of the street, halfway up the hill, at Grant Avenue.

IN ONE half-year seven tons
of clay were converted into what
may fairly be termed the most
unconventional work of sculpture
in the United States. . . . Not only
could no one but Mr. Tilden have
made the "Mechanics' Fountain,"
but it could have been done in no
other city than San Francisco.

Lorado Taft

(right)
*Douglas Tilden's Mechanics Monument, still a fixture of Market Street,
was originally a fountain. Controversy surrounded its turn-of-the-century
dedication when critics objected to the portrayal of nearly nude men.*

(overleaf)
The Palace of Fine Arts in daylight.

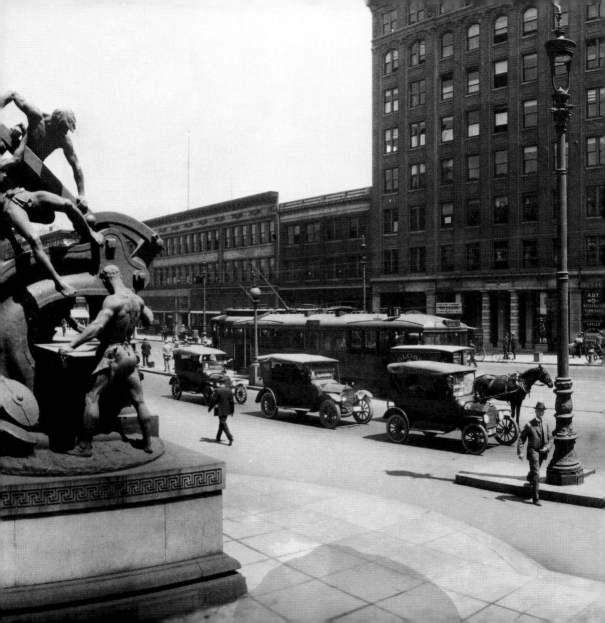

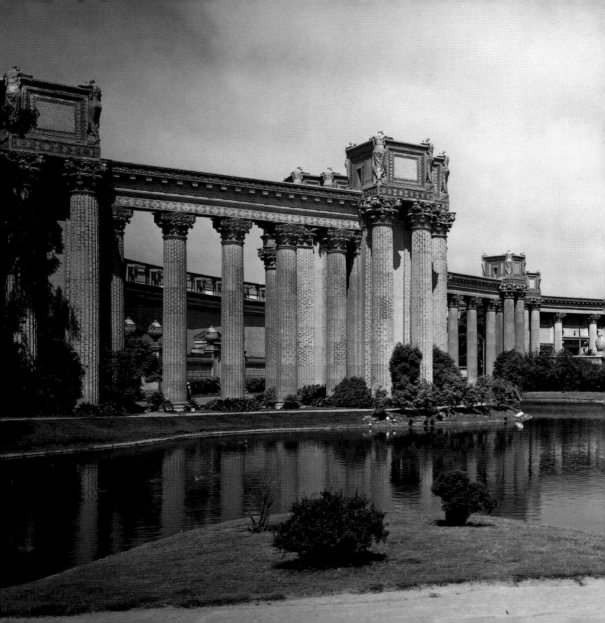

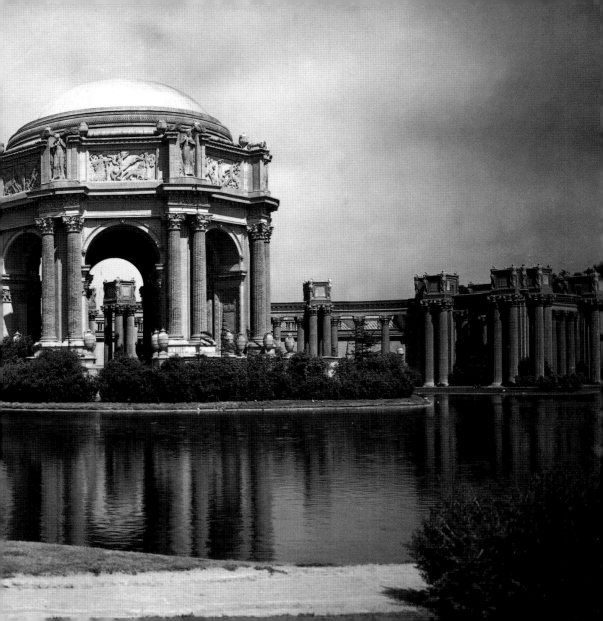

THE INDISPUTABLE record that
the Cliff House burned down three times
and once exploded from a cache of dynamite
mysteriously stored on the premises did
nothing to abate its enviably wicked fame.
Clergymen claimed it was the hand of God;
others ascribed the conflagrations to
mischance with the Cherries Jubilee or
cigarettes actually smoked by women.

Lucius Beebe

The most elaborate of several successive Cliff Houses was built in 1895 and burned in 1907.
Its creator, San Francisco Mayor Adolf Sutro, lived on the hilltop above it.

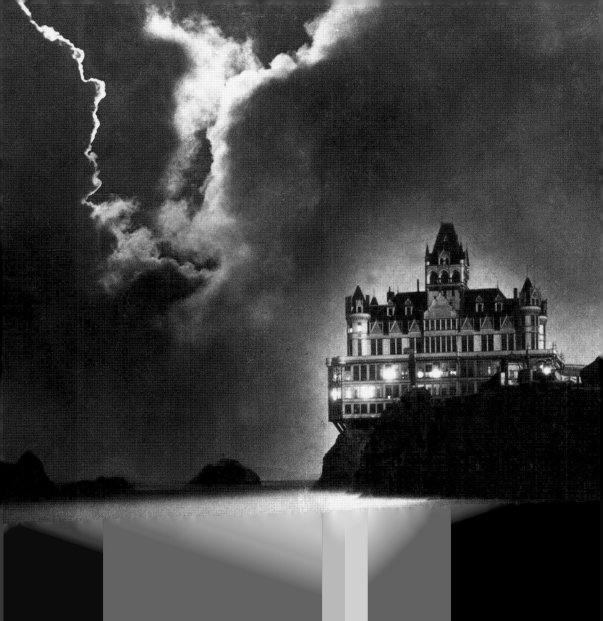

SAN FRANCISCO, the
gateway to the Orient, was a city
of good food and cheap prices;
the first to introduce me to frog's
legs à la Provençale, strawberry
shortcake, and avocado pears.
Everything was new and bright,
including my small hotel.

Charlie Chaplin

*The Palace Hotel's carriage court. Today's Palace Hotel stands on the site
of this original, which was built in 1875 and burned down in 1906.*

32

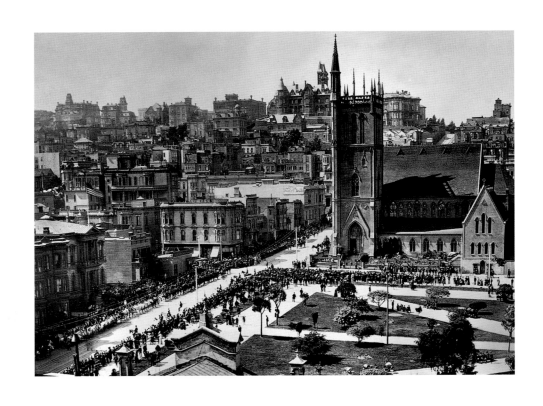

(above)
Homes of the rich and famous overlooked Union Square from Nob Hill in the 1880s.

(right)
Union Square in 1802, as the Dewey Monument was being erected.

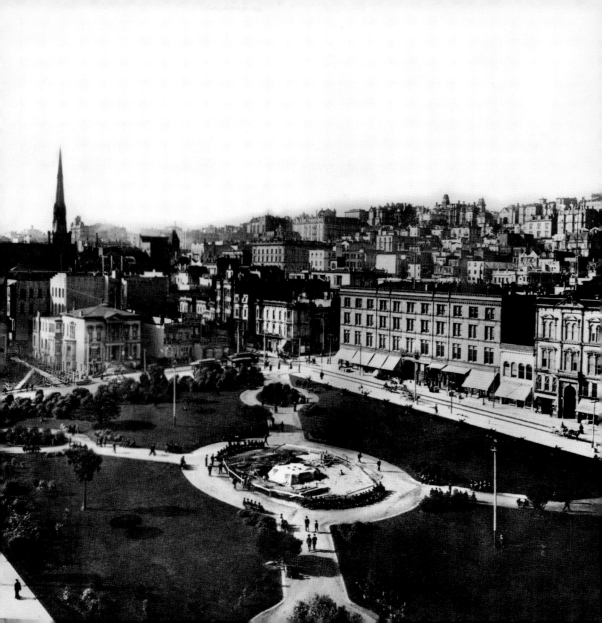

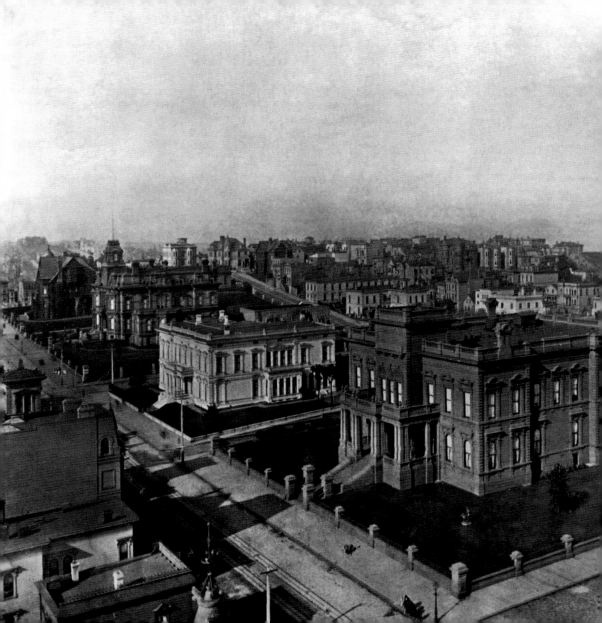

ASIDE FROM the immense fortunes made in the Nevada mines and the Central Pacific railroad—whose outward symbol was a group of huge and hideous mansions on Nob Hill (happily removed by the fire)—many men piled up wealth in the great corporations. . . . Vice was by no means extinguished, but was decently covered up.

Gertrude Atherton

Big money—silver barons and railroad magnates—built atop Nob Hill, once cars made the area easily accessible. This entire scene, with the exception of the Flood home, was swept away in the disaster of 1906. Left to right: The Crocker, Huntington, and Flood Mansions.

shock the smoke of S

was a lurid tower vi

away. And for three

lurid tower swayed ir

sun, darkening the d

with smoke.

R after the earthquake
Francisco's burning
ble a hundred miles
lays and nights, this
he sky, reddening the
, and filling the land

Jack London

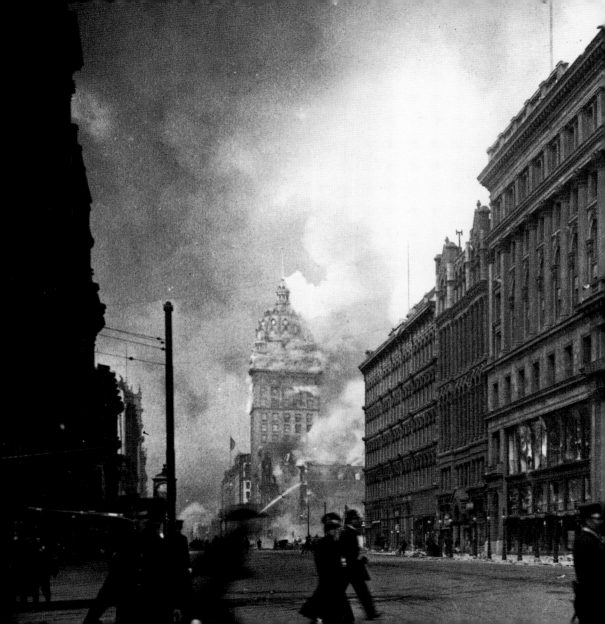

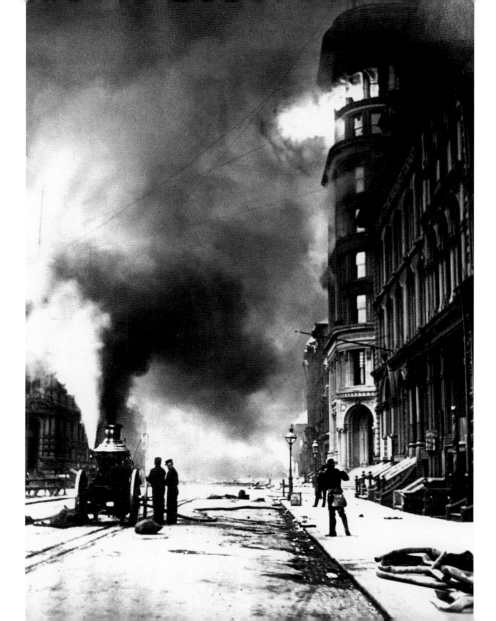

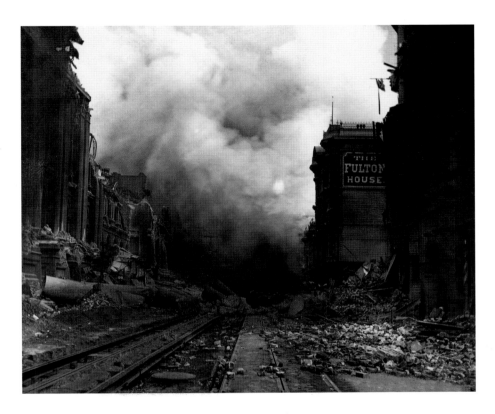

(preceding spread)
Firemen battling the Great Fire on Market Street as flames engulf the Emporium during those three perilous days in April, 1906. Troopers and police are standing by to guard against looters.

(left)
Down California Street, the Mutual Life building blazes in the days following the Great Quake.

(above)
Amidst the rubble, fires rage on Fulton Street.

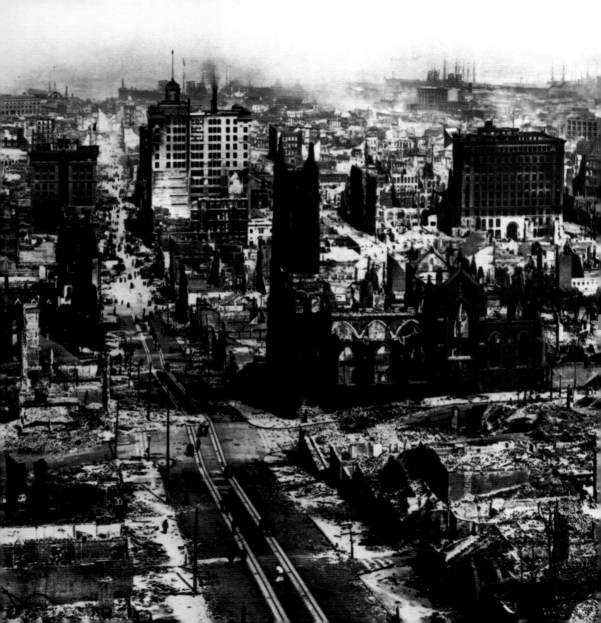

OCT. 23—Mild, balmy earthquake.

Oct. 24—Shaky.

Oct. 25—Occasional shakes, followed by light showers of bricks and plastering.

N.B. Stand from under.

Nov. 1—Terrific earthquake.

Nov. 6—Prepare to shed this mortal coil.

Nov. 7—Shed.

<div align="right">Mark Twain's observations on the quake of 1865</div>

43

Cable car tracks marked California Street in this view from Nob Hill toward the bay shortly after the earthquake and fire of 1906.

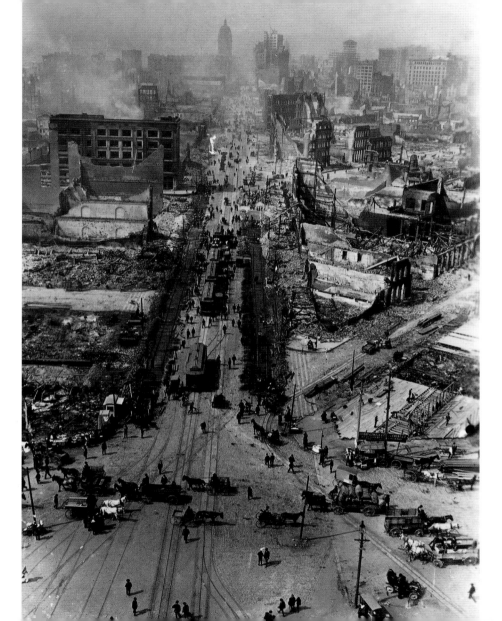

LIFE WENT ON calmly until one morning we and our home were violently shaken by an earthquake. Gas was escaping. I hurried to my father's bedroom. . . . My father was apparently asleep. Do get up, I said to him. The city is on fire. That, said he with his usual calm, will give us a black eye in the East.

Alice B. Toklas

Looking west on Market Square from the Ferry Building some months after the earthquake and fire of 1906.

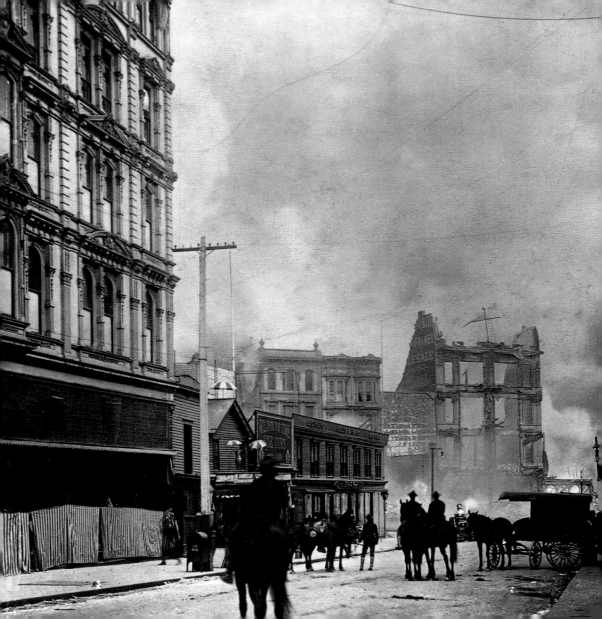

IN THE seagulls' scream, chunk-chunk of ferryboat paddles, naughty giggles in upstairs rooms at the St. Germaine and Blanco's and slap of cable on what Gelett Burgess called "The Hyde Street Grip"—in these things and more, the magic seems to have endured long after '06.

<div align="right">Herb Caen</div>

47

<div align="center">

(left)
*The earthquake of April 18, 1906, and the fire that followed,
destroyed 29,000 buildings in San Francisco.*

(overleaf)
*The appearance of San Francisco immediately after the fire inspired
Lawrence Harris to write a poem that described the rubble as
"The damndest finest ruins ever gazed on anywhere."*

</div>

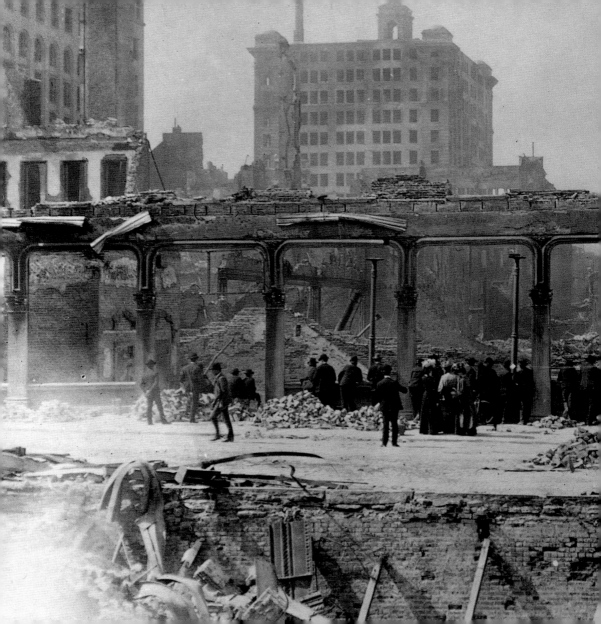

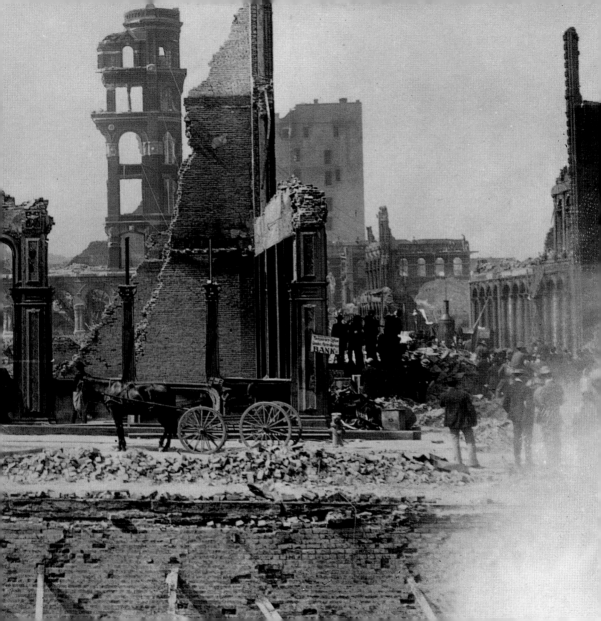

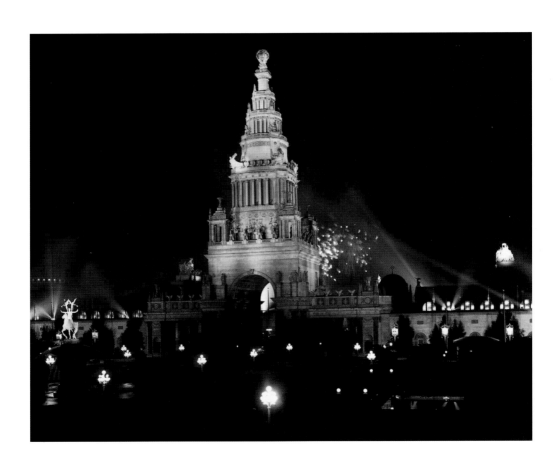

WHEN SAN FRANCISCO was destroyed by fire in 1906, many people predicted that the city would never be rebuilt. A great number of men and women packed their goods and chattels and hastily bade farewell to the still smoking ruins of a City That Was, firmly believing that destiny had determined that it should remain forever buried in its own ashes. . . . We all know now that the Spirit of Energy and Determination did abound in San Francisco. . . the City was not only rebuilt in less than ten years, but, in addition thereto, an International Exposition, surpassing all previous Expositions, was built by its people.

L.C. Mullgardt

(left)
The Tower of Jewels was the dominating center of the Panama-Pacific International Exposition of 1915. The sculpted figures by John Flanagan represented the four archetypes who spearheaded the American westward movement: the adventurer, the priest, the philosopher, and the soldier.

(overleaf)
The Panama-Pacific International Exposition of 1915 celebrated both the opening of the Panama Canal and the rebuilding of San Francisco after the earthquake and fire of 1906. Here, by the Palace of Fine Arts, designed by Bernard Maybeck and still a favorite San Francisco attraction, is the exposition's Fountain of Energy.

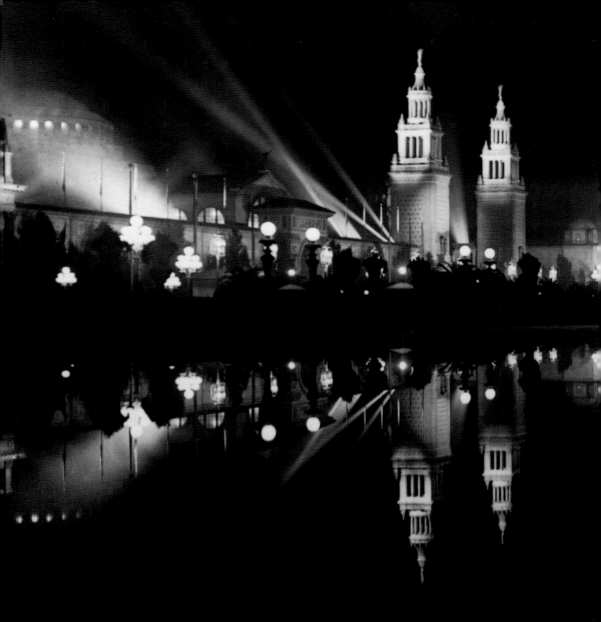

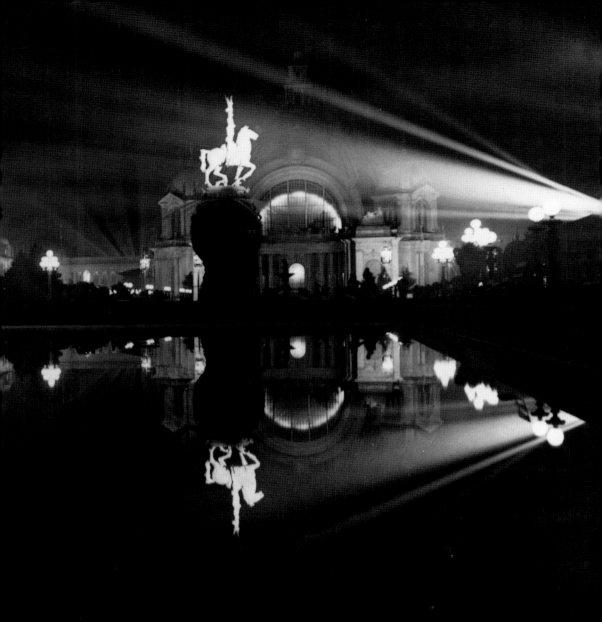

INTERNATIONAL EXPOSITIONS are independent kingdoms in their corporate relations with other countries of the world. They germinate and grow with phenomenal energy. Their existence is established without conquest and their magic growth is similar to the mushroom and the moonflower; they vanish like setting suns in their own radiance.

L.C. Mullgardt, 1915

Reflecting pond in a central courtyard of the 1915 Panama-Pacific International Exposition.

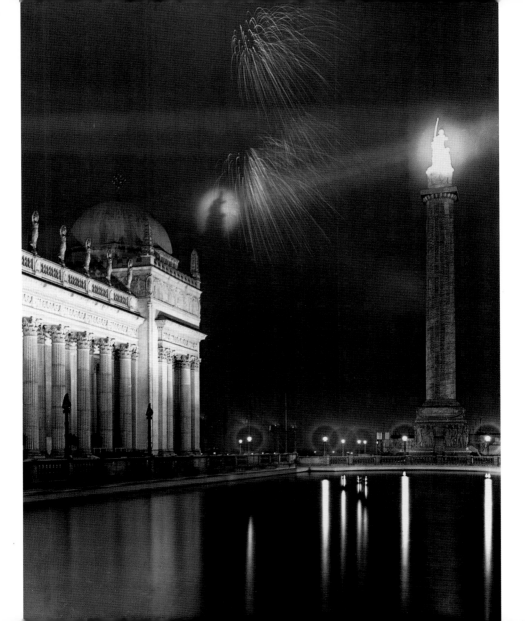

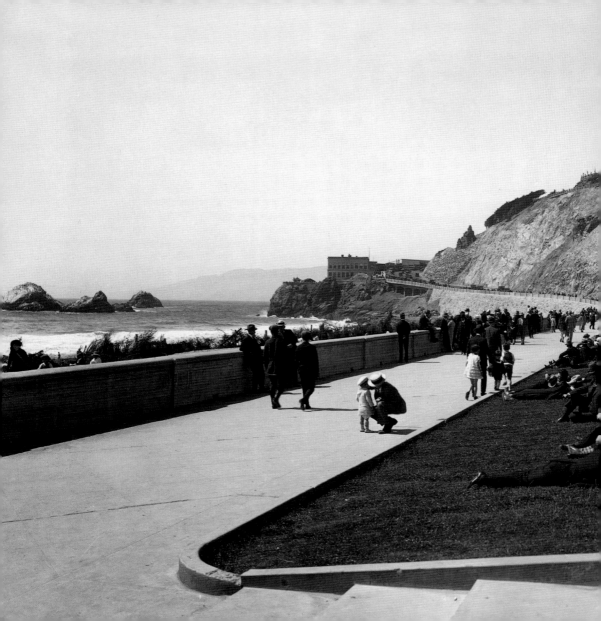

THE TREAT of treating your eyes to true magic—at sundown, on the terrace behind Cliff House, with the endless Beach sprawled out on your left, the Gold Gate yawning with dignity at your right, and Seal Rocks in front of you, thrill-houetted sharply against a sun sinking with amazing swiftness into the great ocean. . . Baghdad-by-the-Bay!"

Herb Caen

*Facing the Cliff House, strollers enjoyed the ocean air
along the edge of the Great Highway, c. 1915.*

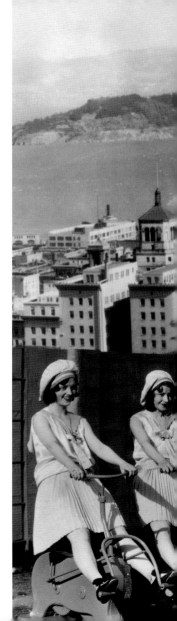

SAN FRANCISCO is a
mad city—a city inhabited for
the most part by perfectly
insane people whose women
are of remarkable beauty.

Rudyard Kipling

*A 1920s campaign promoting fitness—and then fine San Francisco
weather—used this vaguely surreal approach. The Ferry Building tower at
the foot of Market Street is left of the high rise. Angel Island lies beyond.*

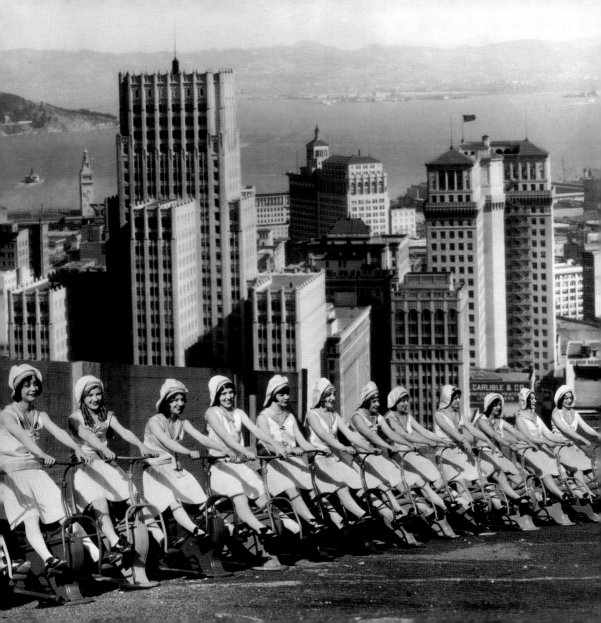

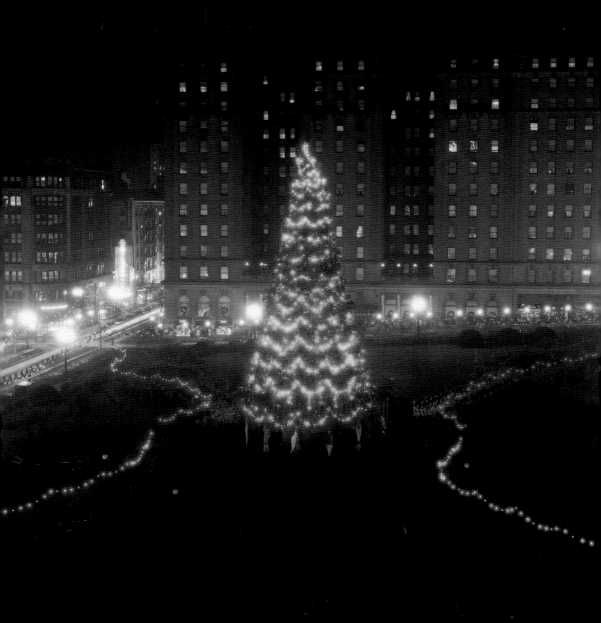

WHAT WAS IT that made the St. Francis so preeminently the hotel of the time [the '20s]. . . certainly the location, in the very heart of the city. But also there was the remarkable staff. What other hotel in town could boast that the attendant of its Turkish bath was a veteran of Kitchener's Camel Corps or that its hotel courier had once shown the sights of Cairo to the visiting royalty of Europe? And what other hotel could boast that its chef had over-thrown the king of Portugal?

David Siefkin

The St. Francis Hotel provided a backdrop for San Francisco's Christmas tree on Union Square in the 1920s.

SAN FRANCISCO in the years before the fire provided a sort of Big Rock Candy Mountain for the entire American people. . . good Americans when they died might, in the terms of the epigram, go to Paris. While they were alive they wanted to go to California. Oceans of champagne, silk hats and frock coats, blooded horses, and houses on Nob Hill, these were the rewards that came to the industrious, the far sighted, or the merely fortunate. What better scheme of things, at least on this side of the river, could any man ask?

Lucius Beebe

The 1908 City of Paris department store was part of San Francisco's Union Square shopping district until it was replaced by Neiman Marcus. Union Square still offers upscale shopping, fine hotels, and a stop on the Powell Street cable car line.

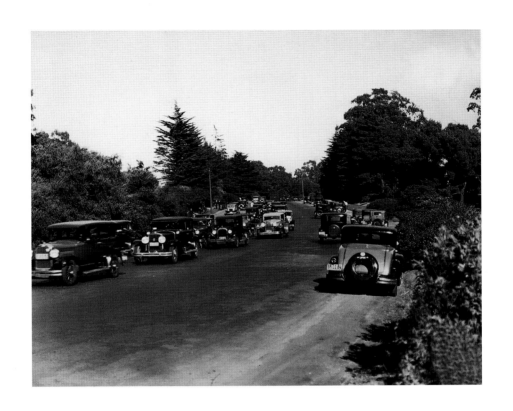

(left)
Lincoln Golf Course, 1932.

(above)
Cars driving through Golden Gate Park in the 1930s. Ever since the advent of the automobile, this has been a favorite route for motor touring in San Francisco.

WHOEVER LAID the town out took
the conventional checkerboard pattern of
streets and without the slightest regard for the
laws of gravity planked it down blind on. . . a
confusion of steep slopes and sandhills. The
result is exhilarating.

John Dos Passos

The curves on the block of Lombard Street between Hyde and Leavenworth streets on Russian Hill were created in the 1920s to make negotiating the 40-degree grade easier and earned this block the sobriquet, "The Crookedest Street in the World."

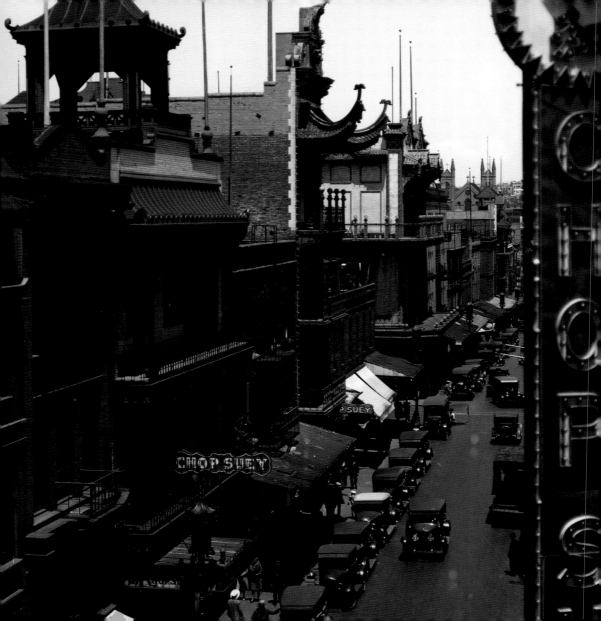

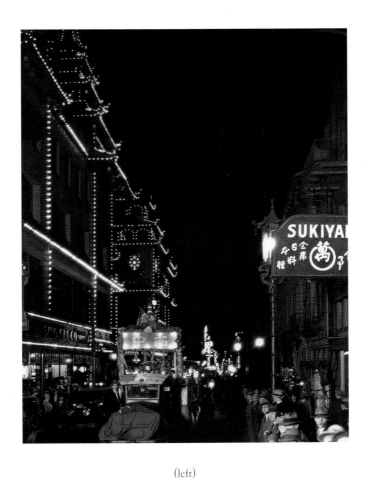

(left)
The first Chinese to settle in San Francisco arrived before the Gold Rush. Soon there was a sizable Chinatown on the east side of Nob Hill; Grant Avenue, shown here, was and is its main street.

(above)
Chinese New Years Parade, 1939.

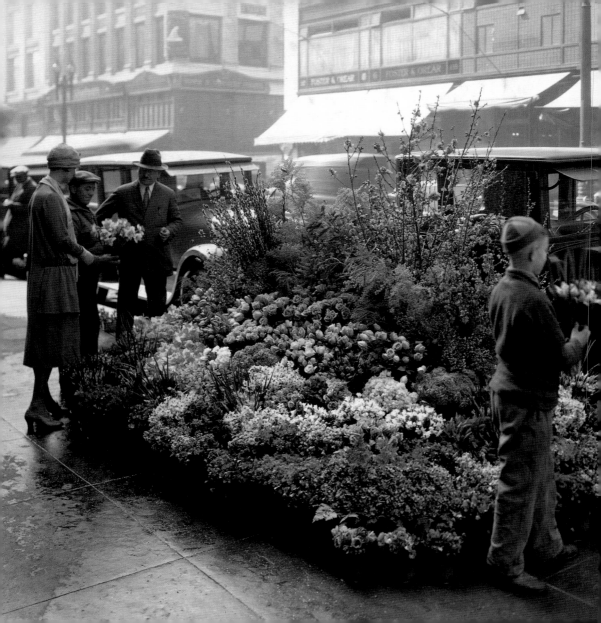

THE FLOWER STANDS that enliven the streets of the shopping district owe their beginning to Michael de Young who allowed the vendors. . . to sell their flowers in front of the de Young Building, protecting them from the policemen. All attempts to suppress them have been halted by storms of protests from press and public.

Federal Writers' Project Works
Projects Administration

71

Grant Avenue near Post Street, c. 1930. Grant's two dozen blocks encompass down-town shopping, Chinatown's main drag, vestiges of North Beach bohemianism, and the touristy Fisherman's Wharf area. It still boasts flower stands.

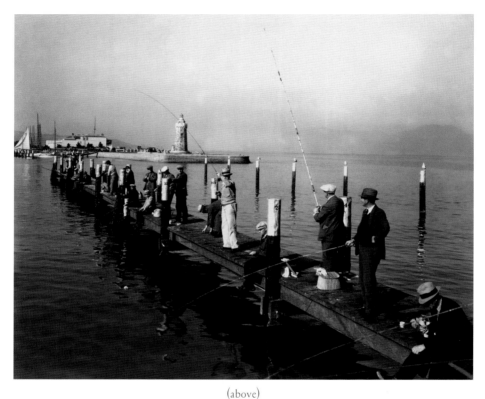

(above)
*San Francisco always was a dressy town. This well-turned-out group tried its
luck in 1932 on a pier facing the St. Francis Yacht Club.*

(right)
Repairing nets at Fisherman's Wharf.

(overleaf)
*Telegraph Hill's Coit Tower was dedicated on October 8, 1933. Among those who painted its Depression-era murals
were Lucien Labaudt, Ralph Stackpole, Bernard Zakheim, Maxine Albro, and Victor Arnautoff.*

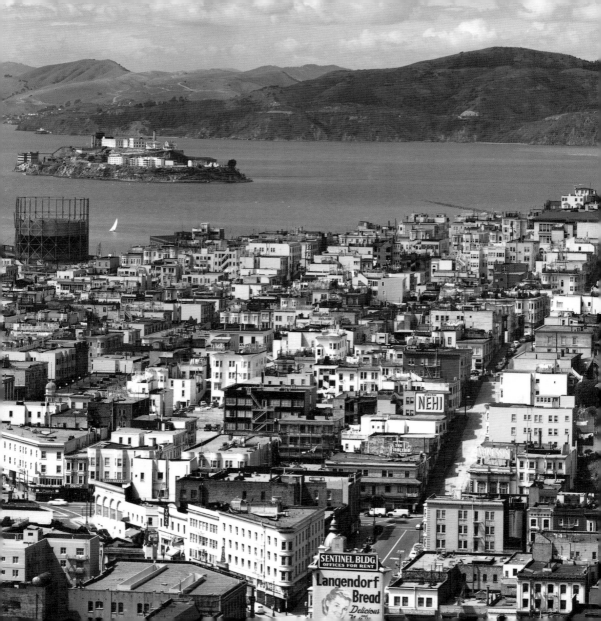

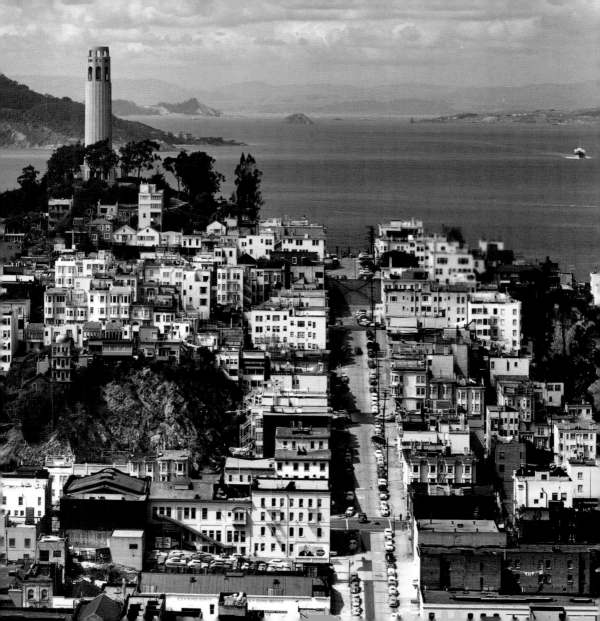

TOURISTS stand smellbound at Fisherman's Wharf, staring in disbelief at the huge pots of boiling water and asking the question they always ask: "You mean you actually throw them in alive?"—as the attendent, too bored to answer, nods curtly and reaches for the sacrificial crab.

Herb Caen

This 1938 view of Fisherman's Wharf area also shows Coit Tower atop Telegraph Hill. Today the area is popular with tourists because of its seafood restaurants, Maritime Museum, 19th-century ships, two cable car lines, and other attractions.

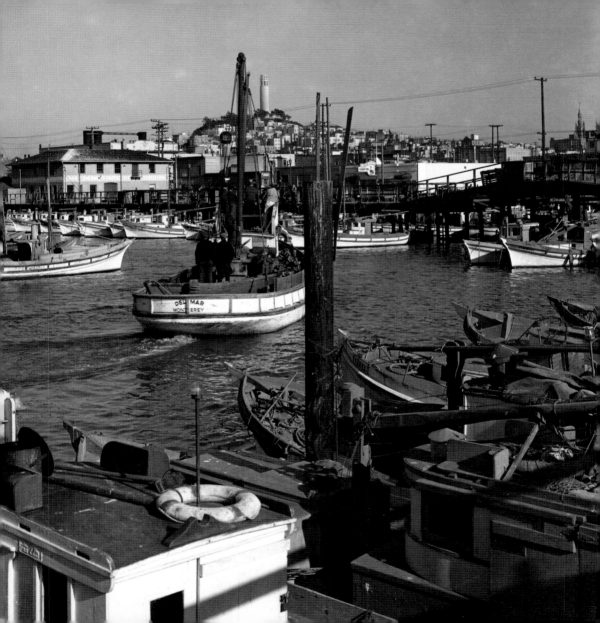

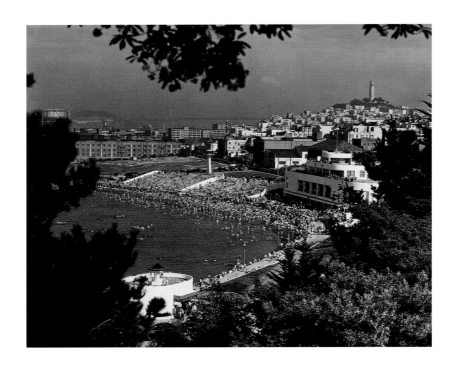

(above)
Now the San Francisco Maritime Museum, the Moderne building at right in this Aquatic Park scene was built by the WPA as a bath house. Coit Tower marks Telegraph Hill at upper right.

(right)
Ocean Beach, shot on a warm day in 1939.

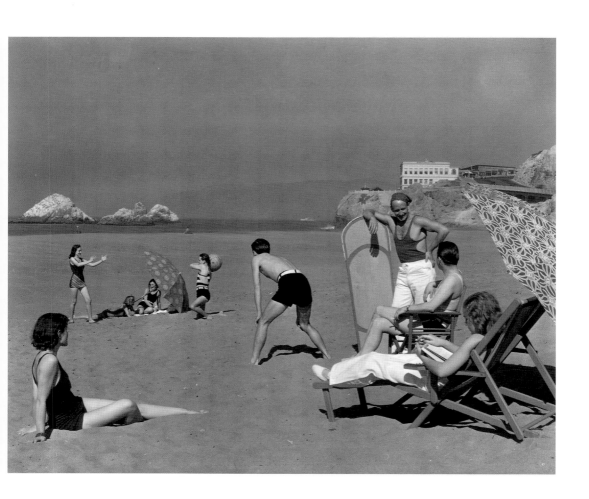

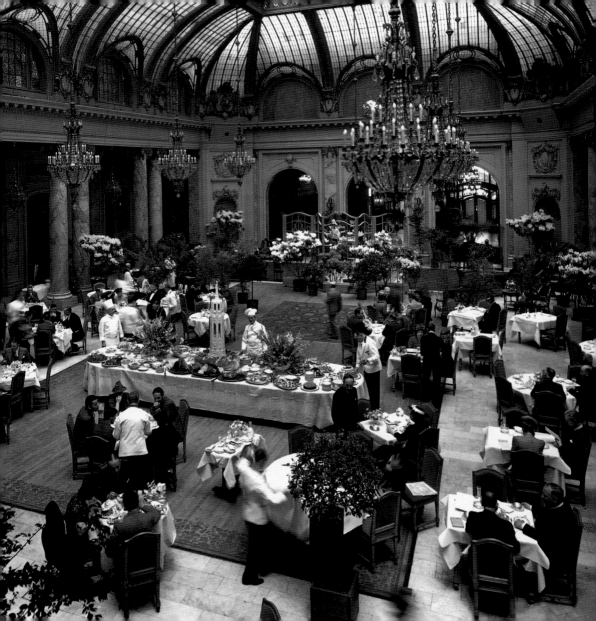

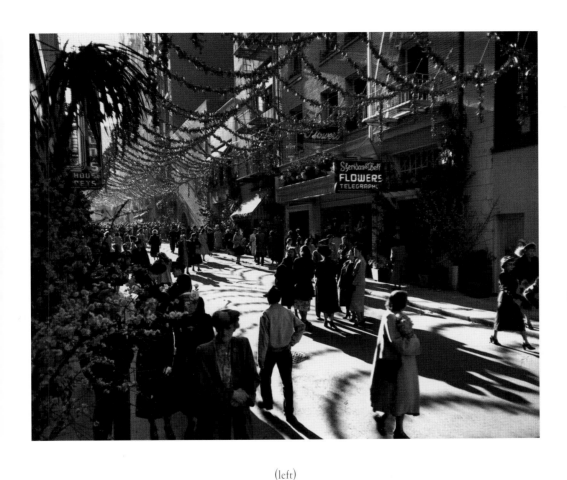

(left)
*The Palace Hotel's Garden Court photographed in 1939. The Garden Court replaced the original
Palace's Carriage Court when the hotel was rebuilt after the earthquake and fire.*

(above)
Maiden Lane off Union Square, 1949.

82

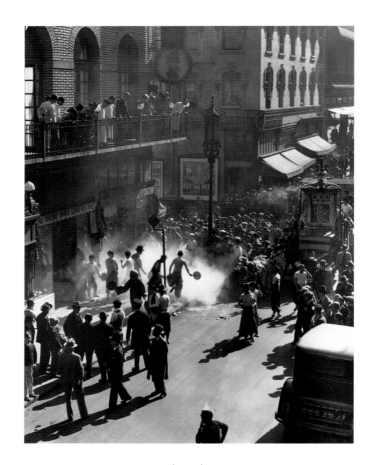

(above)
Chinese New Years Parade, 1939.

(right)
*Grant Avenue is still Chinatown's main thoroughfare in San Francisco,
just as it was when this picture was taken back in 1929.*

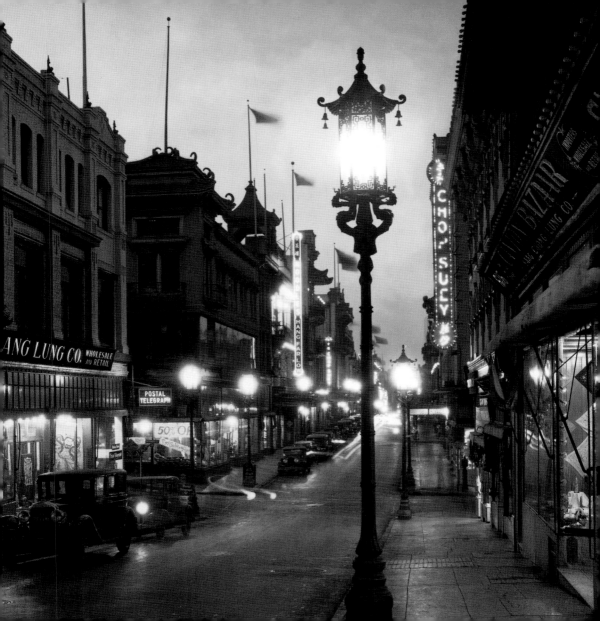

ONE DAY if I do g[...]
to do what every Sa[...]
goes to heaven, I'll l[...]
ain't bad, but it ain't [...]

to heaven, I'm going

Franciscan does who

k around and say, "It

n Francisco." Herb Caen

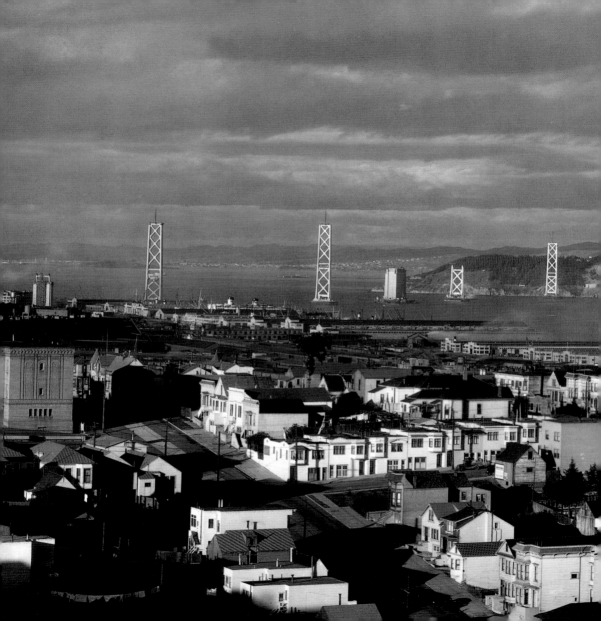

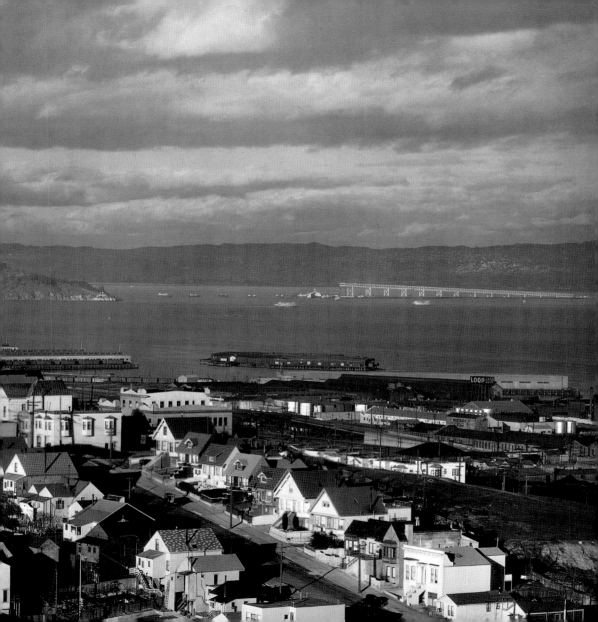

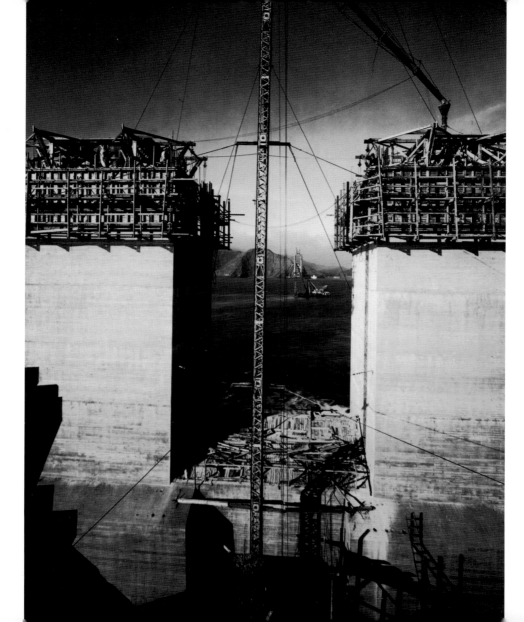

THE FOLLOWING is decreed and ordered to be carried into execution as soon as convenient: That a suspension bridge be built from Oakland Point to Goat island and then to Telegraph Hill, provided such a bridge can be built without injury to the navigable waters of the Bay of San Francisco.

<div style="text-align: right">

Norton I, Emperor of the United States
and Protector of Mexico, 1869

</div>

(preceding spread)
Bay Bridge anchorage, 1934.

(left)
From a South of Market vantage point, near Portrero Hill, the Bay Bridge began to take form in 1935.

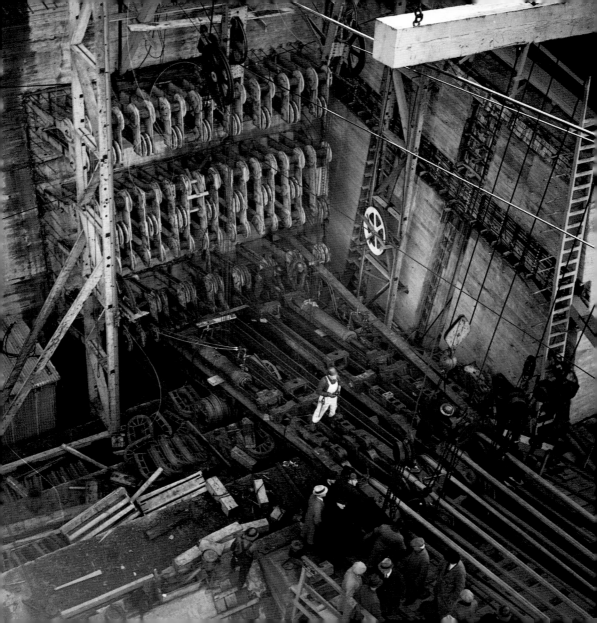

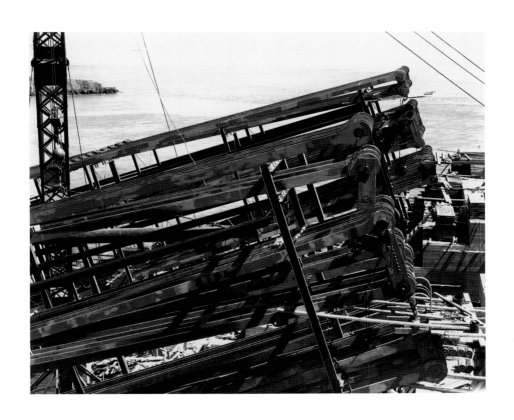

(left)
*Ranks of I-bars embedded in a concrete anchorage stood ready to grip cables
during the construction of the San Francisco-Oakland Bay Bridge, 1935.*

(above)
Golden Gate Bridge cables, 1933.

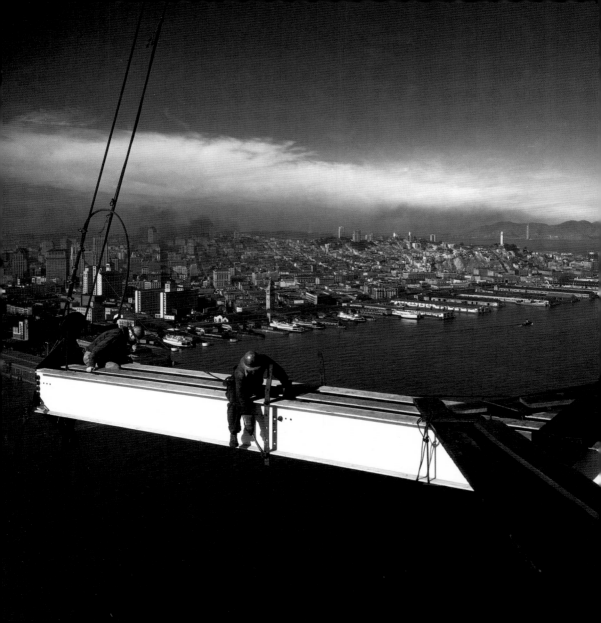

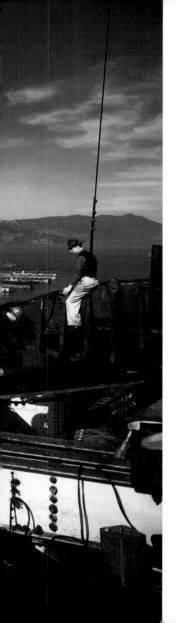

FIRST IN RAPTURE

and first in beauty

Wayward, passionate, brave

Glad of life God gave.

The sea-winds are her kiss,

And the seagull is her dove.

Cleanly and strong she is—

My cool, grey city of love.

<div align="right">George Sterling</div>

The San Francisco-Oakland Bay Bridge, begun the same year as the Golden Gate Bridge (1933), inched toward the city. Coit Tower newly stands atop Telegraph Hill and a Golden Gate Bridge tower rises before Marin hills.

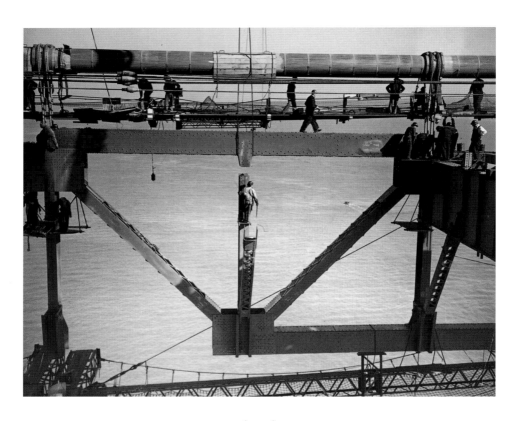

94

(above)
Construction work on the Golden Gate Bridge was dangerous—but steady—in 1935.

(right)
Painters spruced up the Bay Bridge, 1935.

(overleaf)
Construction on the Bay Bridge, 1934.

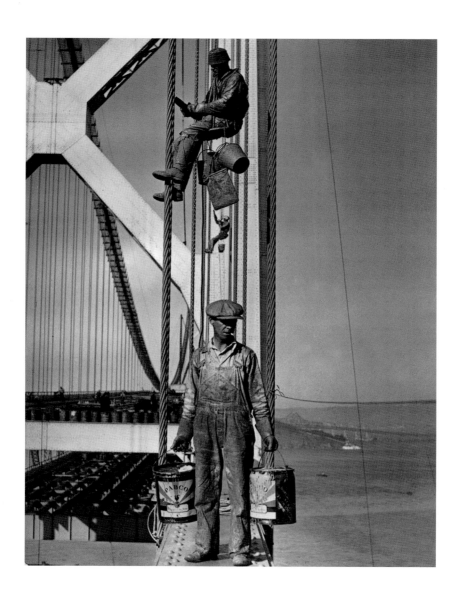

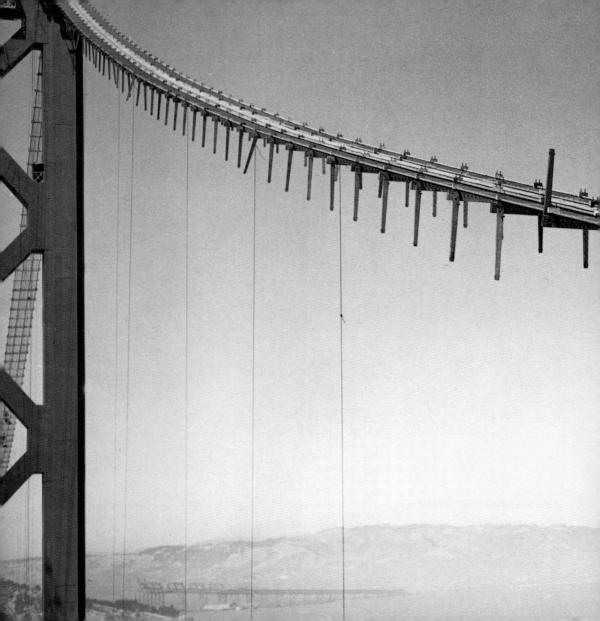

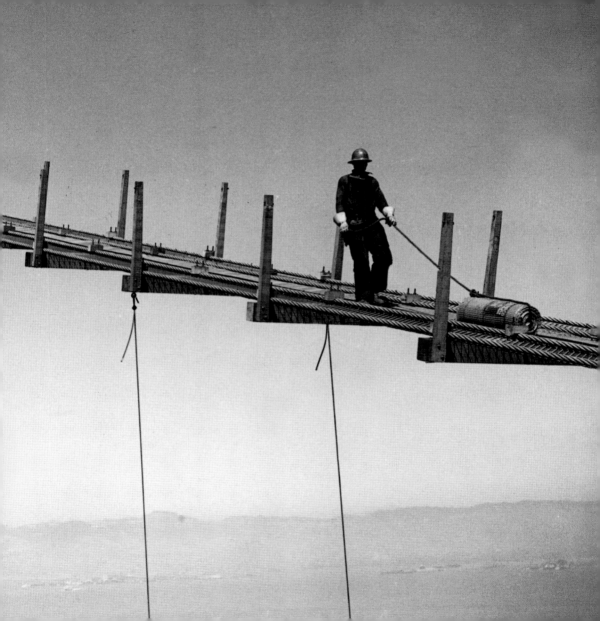

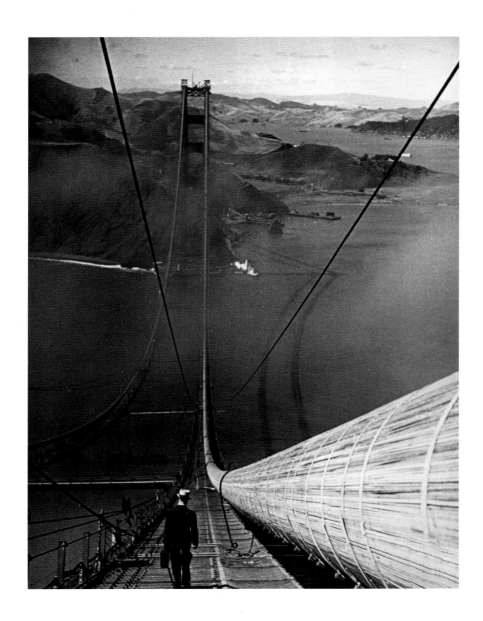

I WENT TO SAN FRANCISCO

I saw the bridges high,

Spun across the water

Like cobwebs in the sky.

Langston Hughes

The Golden Gate Bridge's Art Deco towers rose 746 feet above the water, as this bridge inspector walked to work, 1934.

IF CALIFORNIA

ever becomes a prosperous

country, this bay will be the

corner of prosperity.

Richard Henry Dana

(right)
Cable spinning on the Golden Gate Bridge, 1935.

(overleaf)
*A cantilevered section of the Bay Bridge is being lifted
in place east of Yerba Buena Island, 1935.*

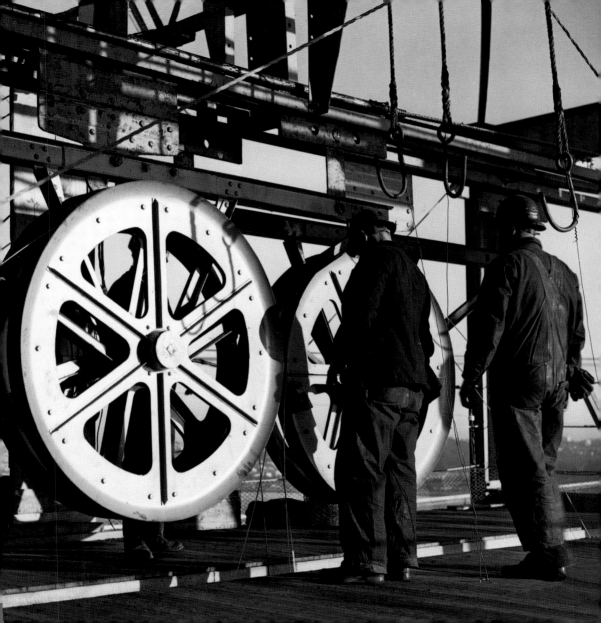

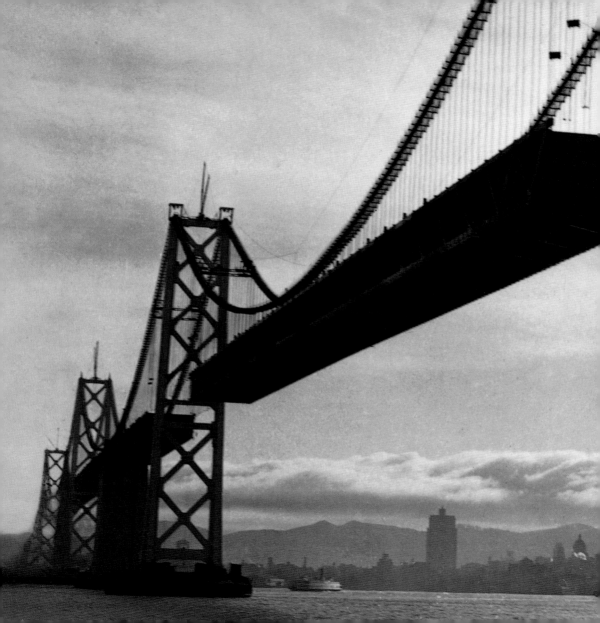

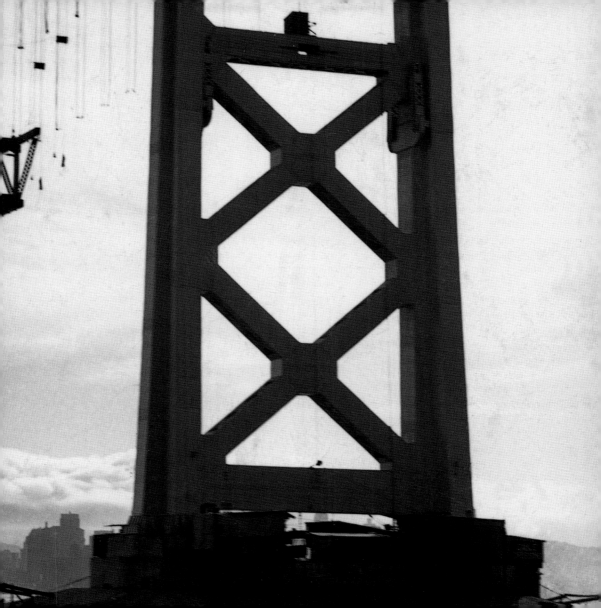

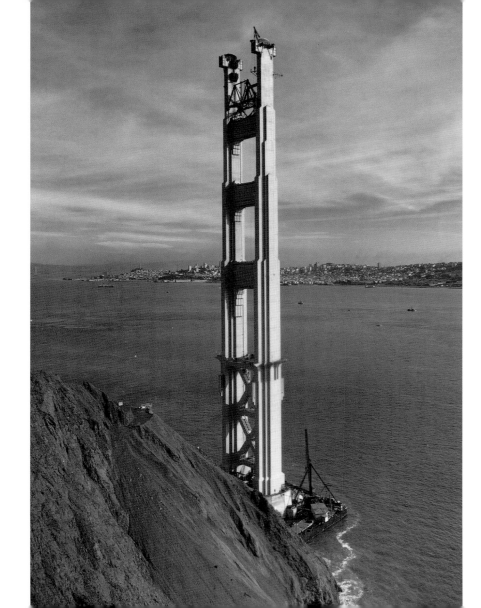

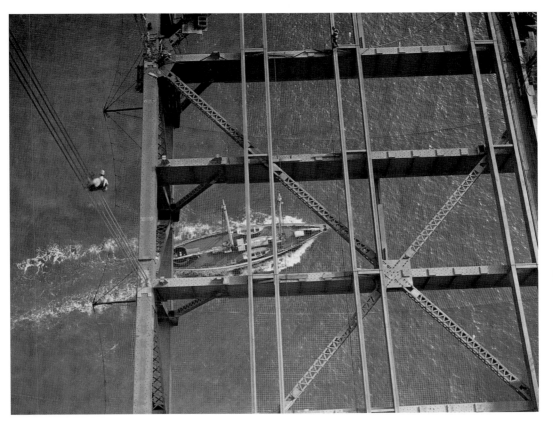

(left)
The North Tower of the Golden Gate Bridge showed off its magnificent profile during construction, 1935.

(right)
Looking down from the Golden Gate Bridge from the vantage point of a bridge builder, 1935.

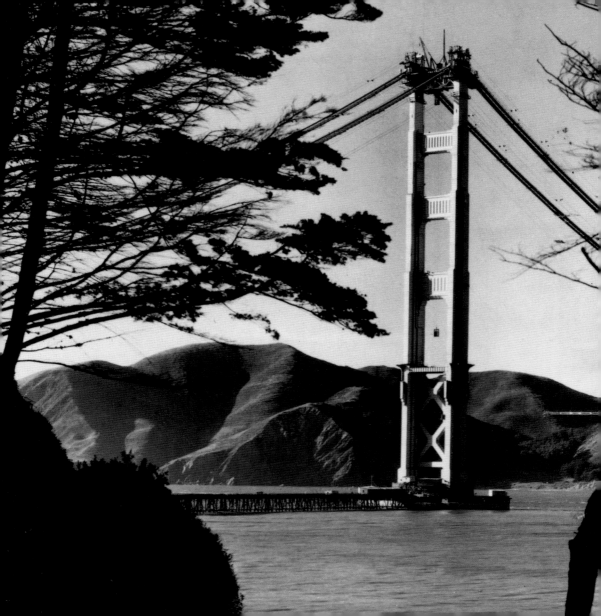

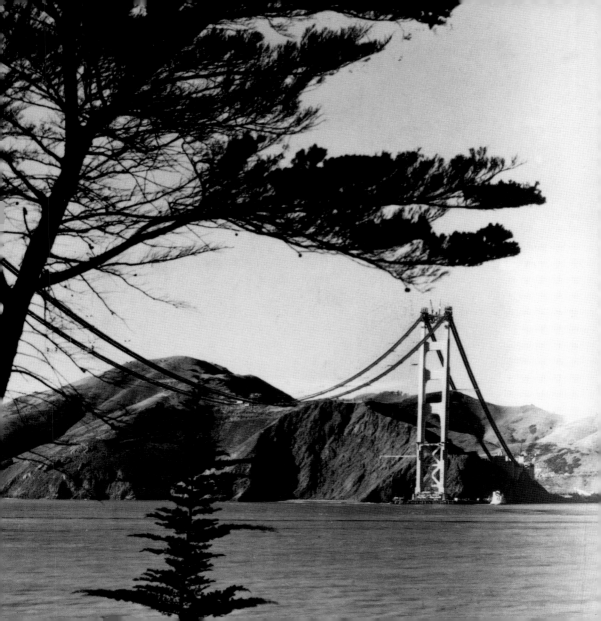

I LEFT my heart in San Francisco

High on a hill it calls to me,

To be where little cable cars

Climb halfway to the stars,

The morning fog may chill the air—

I don't care.

Douglas Cross and George Cory

(preceding spread)
*The Golden Gate Bridge viewed from Crissy Field, 1936. Spanning the Gate created one of the
most striking blends of nature's beauty and human engineering to be found the world over.*

(right)
*The Star of Zealand began life in Bath, Maine, as the Astral, in 1900.
This 1935 view shows her leaving the Golden Gate bound for Japan to be scrapped.*

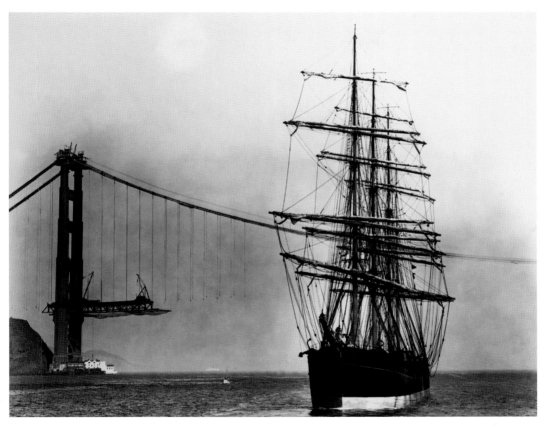

MY WILD-KNIGHT neon
twinkle fate there, ah, and then finally at
dawn of a Sunday and they did call me,
the immense girders of Oakland Bay
still haunting me and all that eternity
too much to swallow and not knowing
who I am at all.

Jack Kerouac

San Francisco-Oakland Bay Bridge, 1936, just before the opening ceremonies.

FANCY A NOVEL

about Chicago or Buffalo, let
us say, or Nashville, Tennessee.
There are just three big cities in
the United States that are
"story cities," New York, of
course, New Orleans, and best
of the lot, San Francisco.

Frank Norris

(right)
Opening day ceremonies for the San Francisco-Oakland Bay Bridge,
viewed from the San Francisco side, November 12, 1936.

(overleaf)
The city celebrating the opening of the San Francisco-Oakland Bay Bridge.

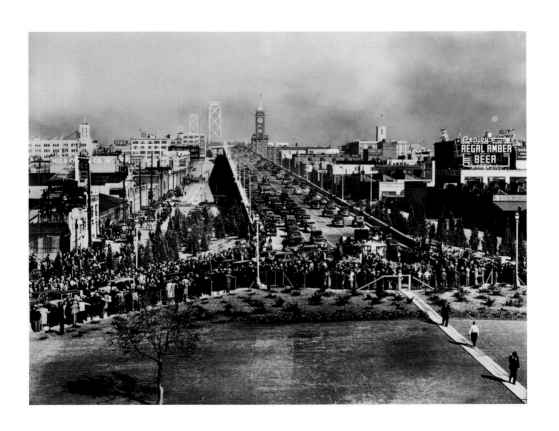

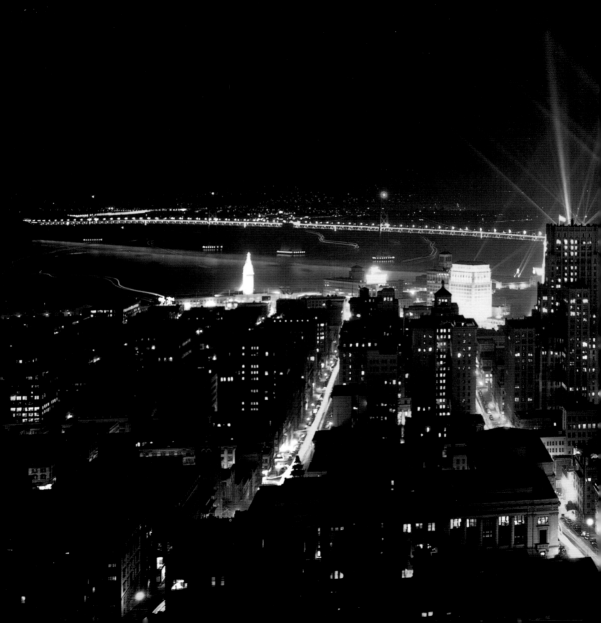

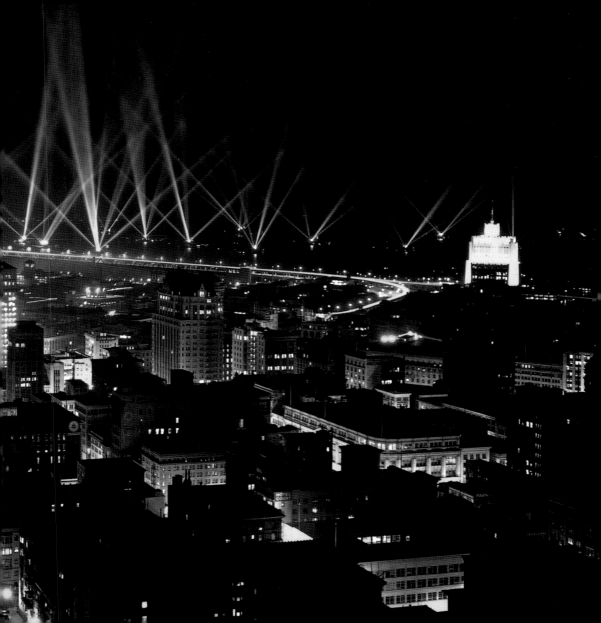

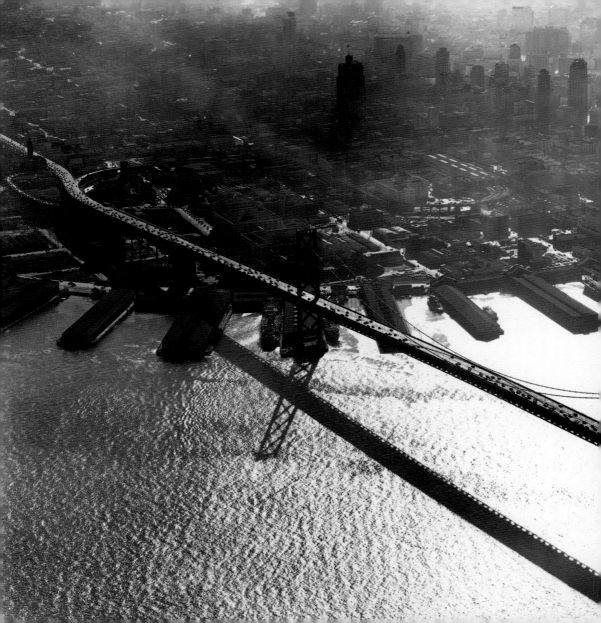

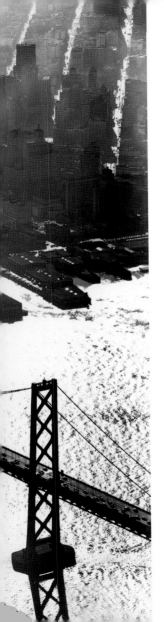

GOD TOOK the beauty of the Bay of Naples, the Valley of the Nile, the Swiss Alps, the Hudson River Valley, rolled them into one and made San Francisco Bay.

Fiorella LaGuardia

An aerial view of opening day on the Bay Bridge, 1936.

THE COAST mountains present an apparently continuous line, with only a single gap. . . . This is the entrance to the great bay. . . . To this gate I gave the name of Chrysopylae or Golden Gate.

Captain John C. Fremont

A flyover was part of the celebration at the opening of the Golden Gate Bridge in May 1937.

I FELL IN LOV

cordial and soc

Union. After the

deserts of Washoe

paradise to me.

with the most
ble city in the
gebush and alkali
San Francisco was

Mark Twain

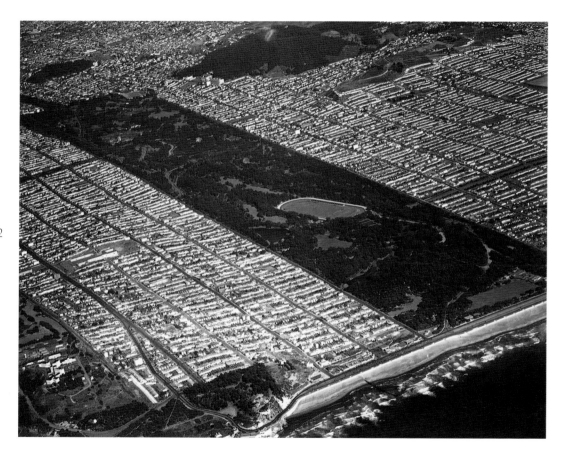

A TRULY horrible punishment—banishment
from Golden Gate Park for life.

Herb Caen

Aerial view of Golden Gate Park from the ocean side, 1966.

124

Fern grove, Golden Gate Park, c. 1930.

Huntington Falls on Strawberry Hill in Golden Gate Park. Built with a donation from railroad magnate Collis P. Huntington, the first flow of the Falls occurred in May, 1894.

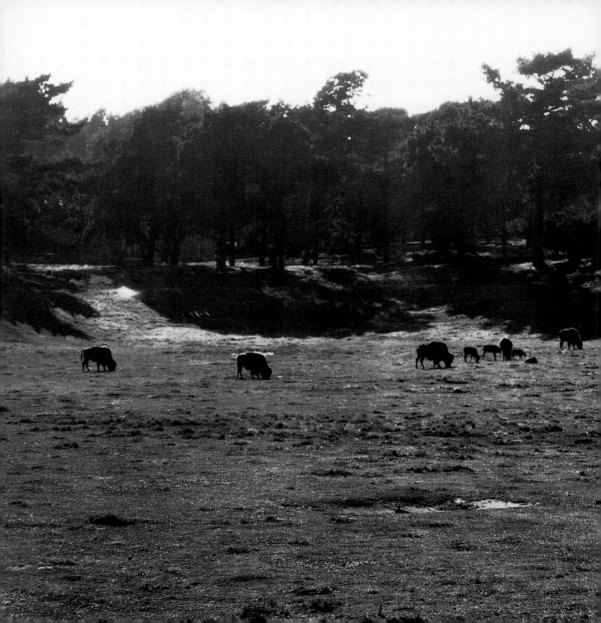

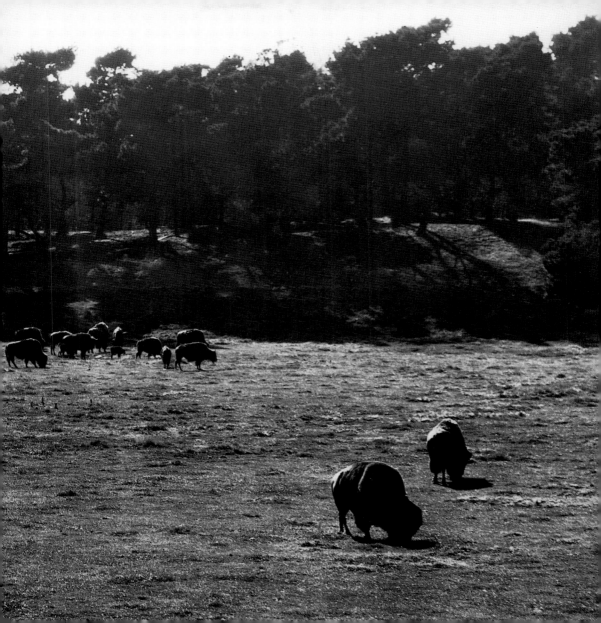

IT WOULD not be wise nor safe
to undertake to form a park upon
any plan which assumes as a certainty
that trees that would delight the eye can
be made to grow near San Francisco.

Frederick Law Olmstead

(preceding spread)
Buffalo graze in Golden Gate Park, 1930s.

(right)
Stone path and footbridge, Japanese Tea Garden, Golden Gate Park, 1937.

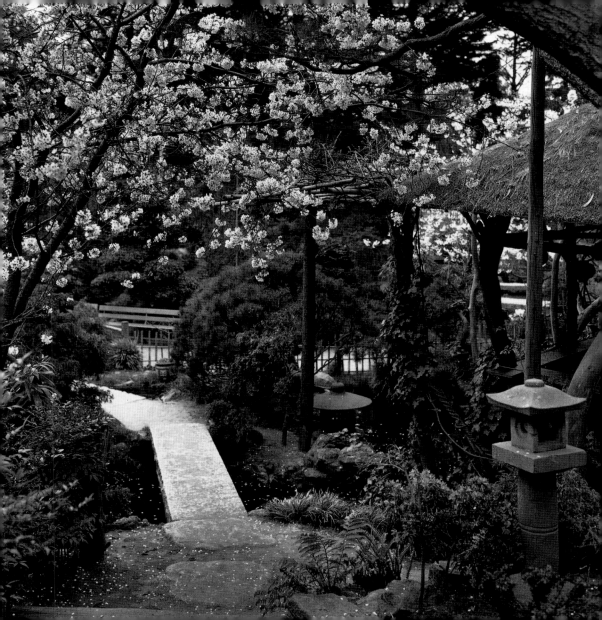

ON AN AVERAGE DAY, Golden Gate Park, aptly named, was home to 99 varieties of light. I counted them. I will mention a few—you can discover the others: the oblique light between eucalyptus leaves at sunrise. The light in the Garden of Fragrance, which is set up as a cornucopia for every sense but sight. The little chunks of colored light that fall on the ground between the light-thin profusion of orchids inside the Conservatory of Flowers. The light on the Hippie Hill, where the first Love-In was held. The light-turning-to-cloud in late afternoon as the Pacific breezes drive in the fog.

Andrei Codrescu

Golden Gate Park was created through an almost miraculous transformation of sand dunes on the city's western edge. One of its features, the Japanese Tea Garden, was a draw at the 1894 California Midwinter Interational Exposition and remains popular today. This view dates from 1938.

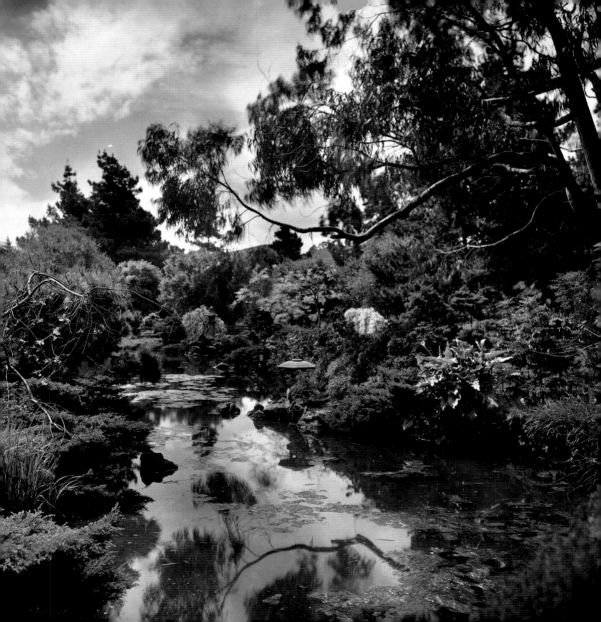

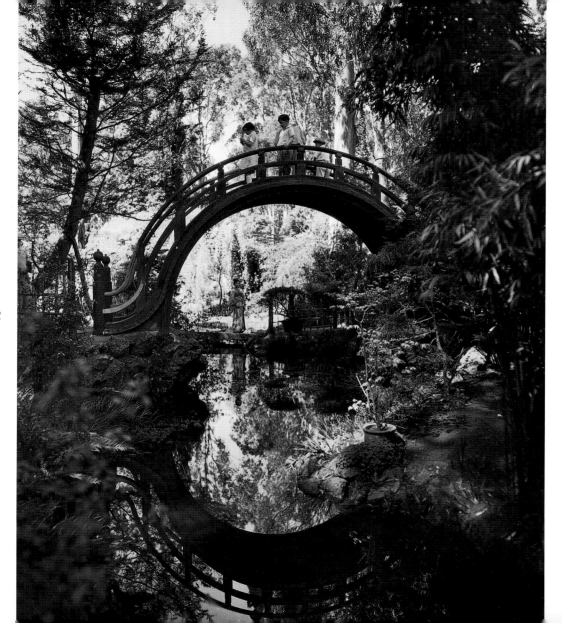

132

THE AIR has an indefinable
softness and sweetness—a tonic
quality that braces the nerves to a
joyous tension, making the very
sense of existence a delight.

Scribners Monthly

The Japanese Tea Garden, shown here in the 1930s, was created by
George Turner Marsh for the California Midwinter International Exposition.
The Moon Bridge, still part of the garden, was among the original 1894 attractions.

THIS IS the season in which I like San Francisco best; although we're nominally a Californian city, there's a certain dreamy quality to the place that's often at odds with the matter-of-factness of sunny day after sunny day. After all, aren't we supposed to be the cool, grey, city of love?

Laurel Wellman

Swans cruise in Golden Gate Park, c. 1900.

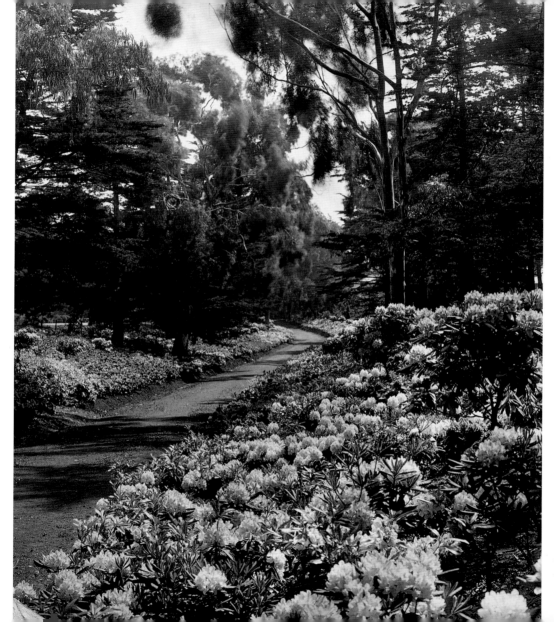

136

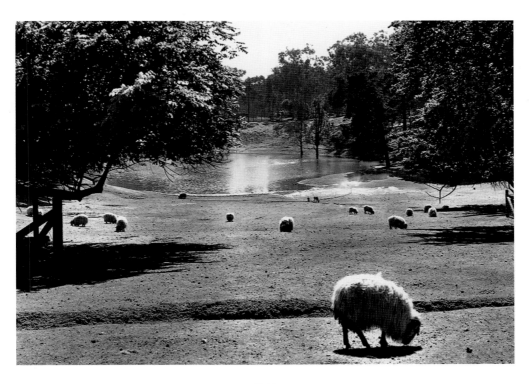

(left)
Rhododendron glen in Golden Gate Park, 1937.

(above)
*Golden Gate Park acquired a dozen sheep around 1900, and in a few years nature's own lawn mowers
numbered about 60. Today, the sheep are gone, but buffalo still roam the park.*

(overleaf)
*The Legion of Honor, originally known as The California Palace of the Legion of Honor,
was a civic gem built in the 1920s and made possible by the generosity of Adolph ("Big Al") and Alma Spreckles.*

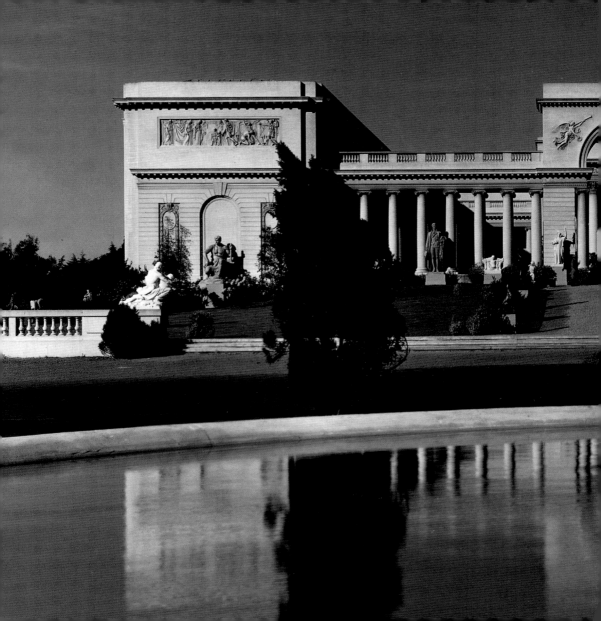

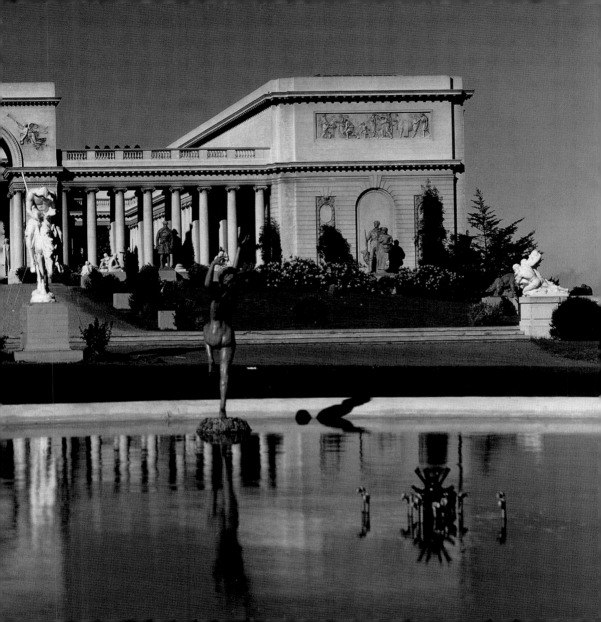

A MADHOUSE of
and frenzied pleasure
the corners chipped
situated and the air
of Edinburgh.

enzied moneymaking

eeking, with none of

off. It is beautifully

eminds one curiously

Aleister Crowley

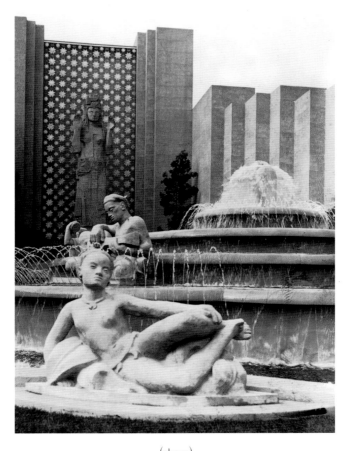

(above)
*Fountain in the Court of Pacifica approaching the Tower of the Sun
at The Golden Gate International Exposition.*

(right)
The Fountain of Life and the Court of Flowers at The International Exposition.

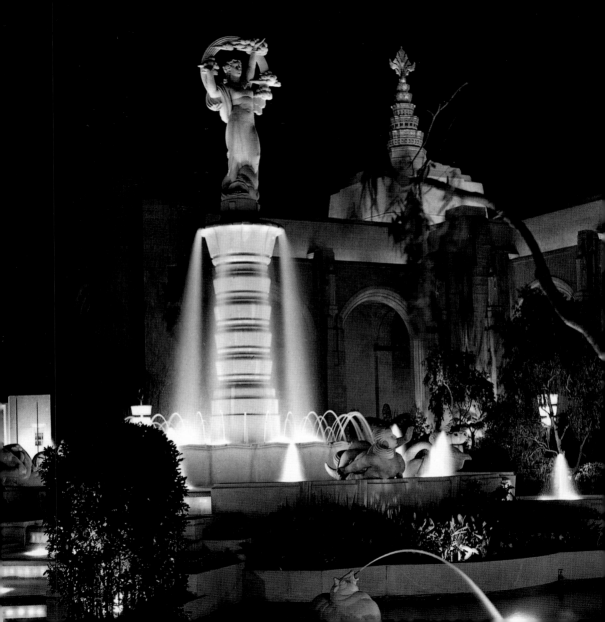

I WALKED through the Court of the Seven Seas to the fountains and gardens of the Court of Honor, dominated by the hour-hundred-foot Tower of the Sun. So tall was the tower that one day someone looked up, saw a wisp of fog drifting past its top, and an illusion that the tower was falling, and screamed a warning that scattered the visitors in all directions.

Harold Gilliam

The Tower of the Sun at San Francisco's Golden Gate International Exposition. The exposition, also known as the Treasure Island World's Fair, opened on February 19, 1939, and closed on September 2, 1940.

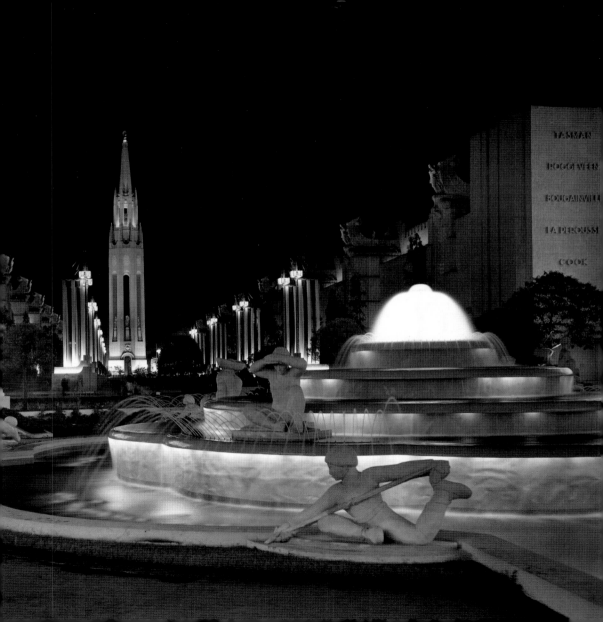

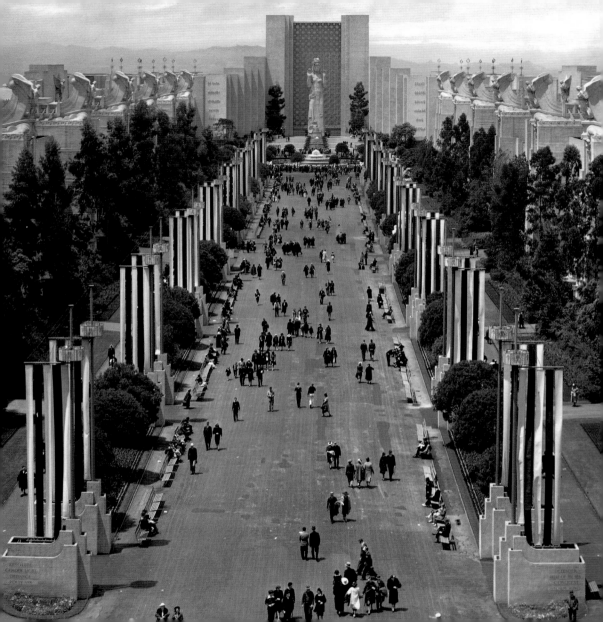

I WENT to the fair every weekend both years and will never forget the moment during the Aquacade show when stout, pompous Morton Downey came out warbling its theme song and the show's star, Johnny Weismuller, pushed him into the pool. "Is this part of the show?" I asked my grandmother. "Absolutely not, Billy. That Morton Downey is a real pill."

Bill Knorp

The Exposition's theme, "A Pageant of the Pacific," emphasized San Francisco's ties with Asia. The Court of Pacifica and Ralph Stackpole's statue "Pacifica" developed this theme. Within two years the onset of war with Japan would temporarily sever these ties.

THE CABLE CARS have for all practical purposes made San Francisco a dead level. They take no count of rise or fall, but slide equably on their appointed courses from one end to the other of a six-mile street. . . . If it pleases Providence to make a car run up and down a slit in the ground for many miles, and if for two-pence-halfpenny I can ride in that car, why shall I seek the reasons of the miracle?

Rudyard Kipling

148

(right)
The cable car was invented in San Francisco; the first run was down Nob Hill in 1873. All three cable lines still in service climb Nob Hill. Today, as in the 1950's, two of them use this turntable at Powell and Market Streets.

(overleaf)
Commerical shipping at Islais Creek, 1950. Things had changed since the Ohlone word islay, *meaning "wild cherry," gave the area its name.*

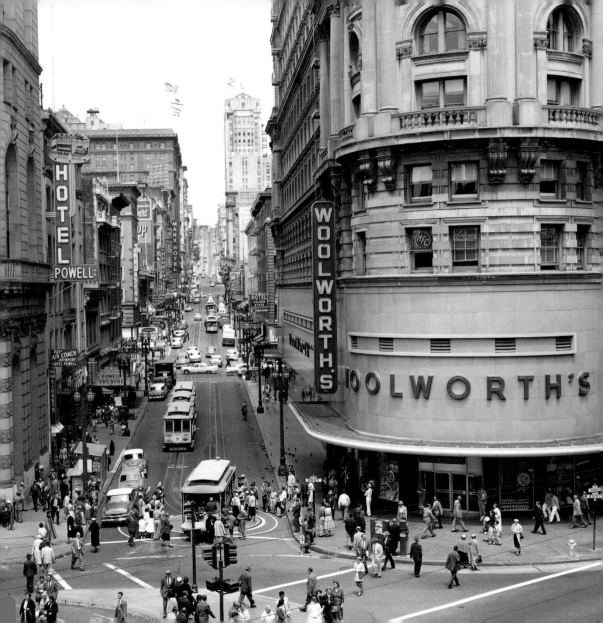

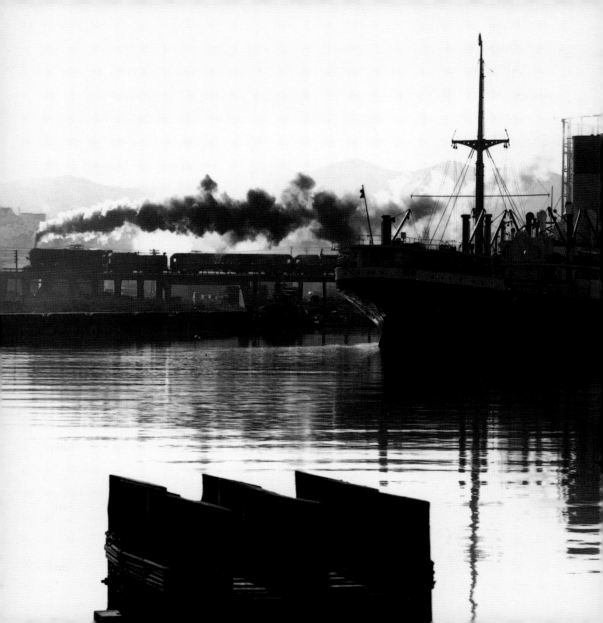

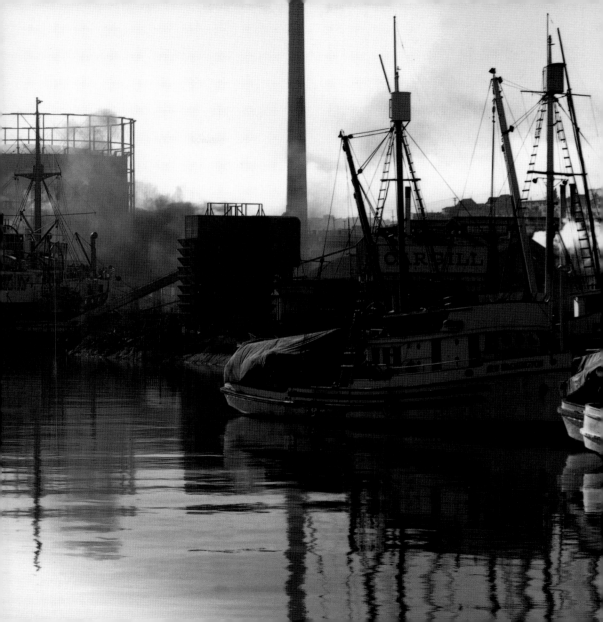

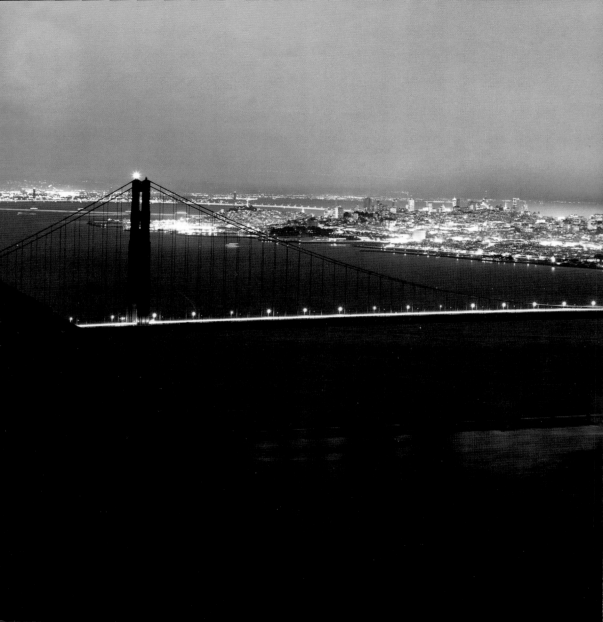

ONE OF the sensations of which I never tire is the four-wheeled plunge into a fog-shrouded Golden Gate Bridge, all windshield-wipered wetness, and the sudden emergence into a sun-swept Marin, with its delicious summer smells and promise of secret groves. Nowhere else in the world can the transition from concrete jungle to pastoral retreat be made so swiftly and dramatically. Savor it.

Herb Caen

153

(left)
The Golden Gate Bridge as seen from the Marin Headlands, 1963.

(overleaf)
An aerial view of Alcatraz Island in 1967. Alcatraz is taken from the Spanish word for Pelican. Although pelicans can be found on the island, Alcatraz is mostly known for being a home for a much tougher kind of bird.

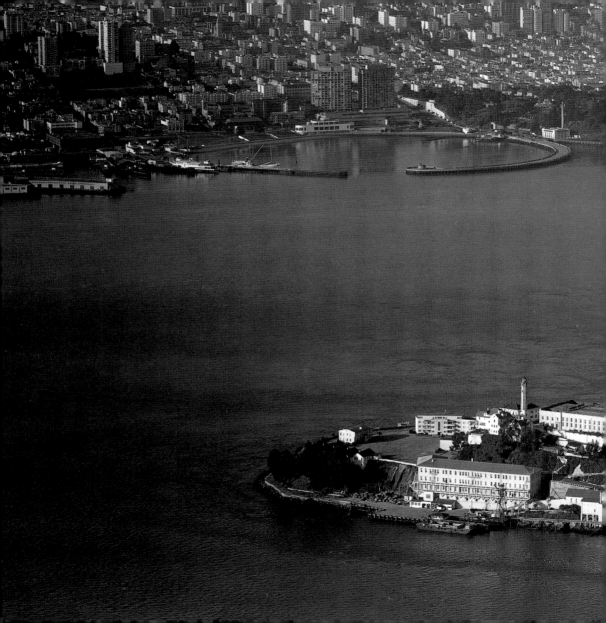

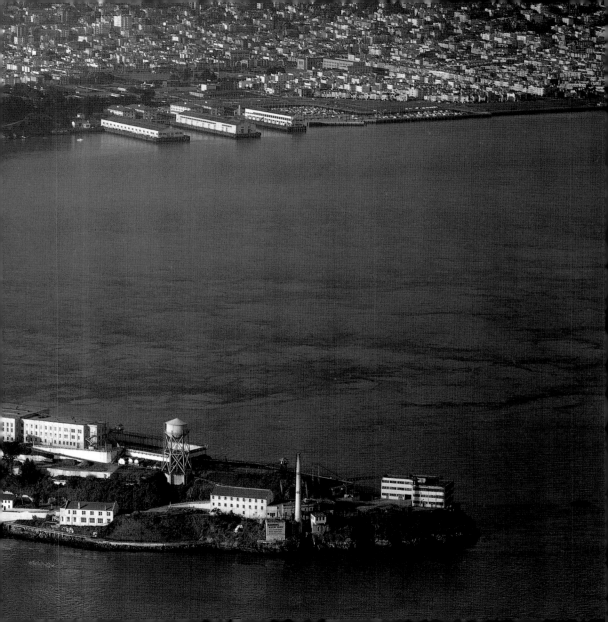

SAN FRANCISCO has only one drawback. 'Tis hard to leave.

Rudyard Kipling

The Golden Gate Bridge.

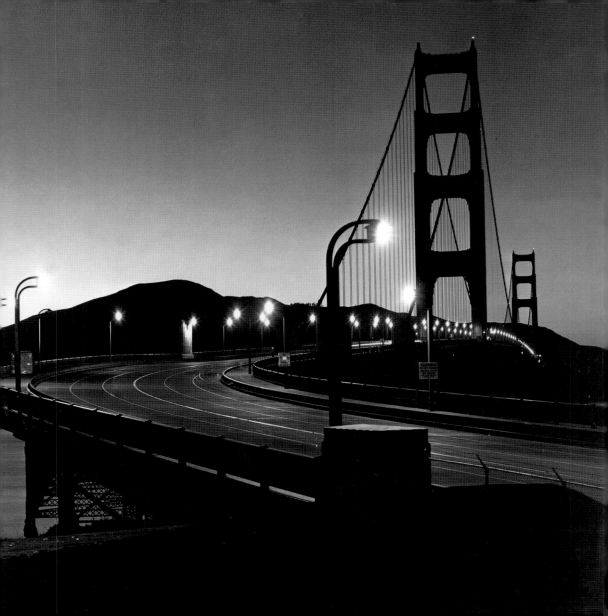

Published in 2003 by Welcome Books®
An imprint of Welcome Enterprises, Inc.
6 West 18th Street, 3rd Floor
New York, NY 10011
Tel: 212-989-3200
Fax: 212-989-3205
e-mail: info@welcomebooks.biz
www.welcomebooks.biz

Publisher: Lena Tabori
Editor: Peter Beren
Art Director: Gregory Wakabayashi
Designer: Naomi Irie
Project Director: Natasha Tabori Fried
Editorial Assistant: Lawrence Chesler

Distributed to the trade in the U.S. and
Canada by Andrews McMeel
Distribution Services
Order Department and Customer Service
(800) 943-9839
Orders-Only Fax (800) 943-9831

158

Compilation and Design © 2003
Welcome Enterprises, Inc.
Photographs © 2003 Moulin Studios

Additional copyright available on the
following page.

Library of Congress Cataloging-in-
Publication Data on file.

Printed in Hong Kong

First Edition

10 9 8 7 6 5 4 3 2 1

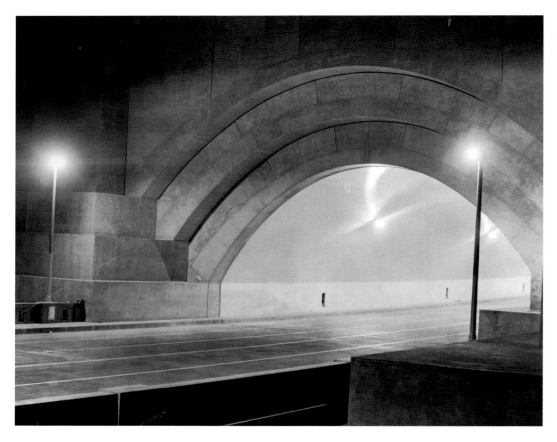

*The Yerba Buena Tunnel of the San Francisco-Oakland Bay Bridge
the night before opening day, November 12, 1936.*

federal arbitration leads to the accession to most of ILA's demands. • Once used to hous
Army prisoners, Alcatraz island begins to receive other penitentiaries' worst inmates
Known as "The Rock," the jail houses such famous inmates as Al Capone, George
"Machine" Gun Kelly, and Robert Stroud ("The Birdman of Alcatraz"). 1935 The San
Francisco Museum of Modern Art opens. 1936 The San Francisco-Oakland Bay Bridge
is completed. Both trains and cars can travel on the bridge. 1937 The Golden Gate
Bridge is completed. 1939–40 The Golden Gate International Exposition is held in
San Francisco. Also known as the Treasure Island World's Fair, it opens on February 19
1939 and closes on September 2, 1940. 1942 Japanese Nationals and Japanese American
are evacuated from the West Coast and interned in prison camps on Angel Island in San
Francisco Bay, among other sites. 1945 Representatives from 50 countries gather in San
Francisco to sign the United Nations charter. 1946 San Francisco becomes home to the
49ers football team. 1954 Baseball great "Joltin' Joe" Di Maggio marries Marilyn
Monroe at city Hall. 1958 Rice-a-Roni, the "San Francisco treat," is introduced to the
world by the DeDomenico family. • The Giants, a legendary New York baseball team
move to San Francisco. 1963 On March 21, Alcatraz is closed and its inmates are all
transferred elsewhere. 1967 The Summer of Love blossoms in the Haight-Ashbury
District and the city becomes a mecca for hippies the world over. 1969 The
Exploratorium, the museum of science, art, and human perception, is founded by Dr
Frank Oppenheimer. 1969–71 Indians of All Tribes, Inc. occupy the now deserted
island of Alcatraz as a symbol of Native American political activism and protest. 1973
Congress creates the Golden Gate National Recreation Area, including Alcatraz Island, as
part of a new National Park Service unit. The Island opens to the public in the fall and